THE ART OF **GUY CHASE**

JAMES ROMAINE

Square Halo Books

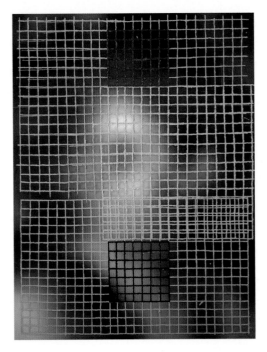

HER OPINION
CHANGED
EVERYTHING
2010
OIL WITH INKJET
PRINT ON
CANVAS ADHERED
TO BIRCH PANEL
55" x 41"

Special thanks to Bethel University for their generous support of this book. To learn more about the art program at Bethel, visit www.Bethel.edu/galleries.

To see more of the artist's work, visit www.GuyChase.net.

©2011 Square Halo Books, Inc.
P.O. Box 18954
Baltimore, MD 21206
www.SquareHaloBooks.com

ISBN 0-9785097-3-0
Library of Congress Control Number: 2011920568

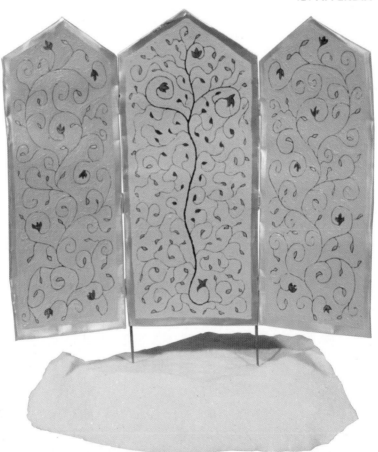

UNTITLED (VINE AND MIRROR) 1989 ACRYLIC ON ALUMINUM WITH MARBLE BASE 11" x 10.5"

NEGATIVE THINKING
WHY I DON'T LIKE GUY CHASE'S ART

The art of Guy Chase breaks two cardinal rules of art appreciation. The art appreciator's motto is, "I don't know much about art, but I know what I like." However, the truth is that we all have a tendency to like what we already know. Therefore, art appreciation tends to favor art with both recognizable and reaffirming subject matter. As it adds to an understanding of the motivation and importance of Guy Chase's art, our attachment to art appreciation, especially as manifested in the Christian community, is a foil against which Chase strategically pushes.

While the issues associated with art appreciation are no more prevalent in the Christian community than they are anywhere else, they are often manifested differently. Furthermore, to the degree that the visual arts are vessels of the sacred, the issues that Chase's art address, such as visual inattentiveness and intellectual complacency, are more than artistic ones; they touch our very exercise of faith. Chase has chosen (or "been called"—the question of choice and determination is actually central to Chase's art) to work with the Christian community, by teaching at several Christian institutions, most recently Bethel University, and participating in organizations such as CIVA (Christians in the Visual Arts). Within this community, Chase continues to gracefully challenge certain pervasive attitudes toward the visual arts.

This book, to accompany an exhibition at Bethel University, serves at least two purposes. It represents a comprehensive collection of Chase's art. As much as possible, every aspect of Chase's artistic production has received attention. *The Art of Guy Chase* also brings together four essays, which collectively survey Chase's art and examine some of the critical issues that surround it. Each of these authors have, like Chase, elected to live, create, and serve within the community of Christians active in the visual arts. Their essays, in part, articulate the challenges that Chase's art represent within this context. Therefore, *The Art of Guy Chase* is more than a historical record, a backward-oriented view of a life's work. I believe that this book and, more importantly, the art of Guy Chase itself might have a prophetic and changing impact on the critical question of what it means to be an artist of faith working in the twenty-first century—that is, if we can only let go of "appreciating" Chase's art.

In art appreciation, recognizability is paramount; this can manifest itself in two ways. The most common form of recognizability in art is pictorial subject matter. The art appreciator is most likely to approve of art with identifiable and familiar imagery. An image that looks like a landscape or Jesus, or both, is most likely to attract admiration.[1] While this sort of narrative-oriented imagery can quickly lead to boredom,

OPPOSITE
**THE
COMMUNITY
DRAWN TO
HER LAUGHTER
WAS A HEAVY
GIFT TO ME** detail
2010
OIL AND ACRYLIC
WITH INKJET ON
CANVAS ADHERED
TO BIRCH PANEL
40" x 30"

1

become the protagonist of the work's narrative. This is one reason why artists with compelling narratives, or mythologies, such as Vincent van Gogh, are favorites of art appreciators.

Guy Chase's art, such as his series of paintings of legal pad pages, often appears to provide the viewer with neither representational nor stylistic constancy. His art, such as his net-and-web drawings, at least initially, suggests little pictorial or personal narrative. Yet his work is born out of his own personal experience. In this process, Chase strategically poses a question: "What is it, if it is not pictorial representation nor stylistic constancy, that makes something 'art'?"

Perhaps this question could be addressed by contrasting the terms "artistic method" and "artistic style." For example, the "artistic method" of Impressionism developed, organically and authentically, out of certain historical contexts of the middle of the 19th century in France. Impressionism didn't happen simply because Claude Monet woke up one day and thought, Why don't I go paint outside? (as if no prior artist had thought of this). However, the availability of oil paint in portable tubes and the steam-powered train made painting *en plein air* not only a possibility but even an imperative. Vincent van Gogh understood that the particularized mark-making of Impressionist painting signified a methodical, or mechanized, process of seeing the world of the industrial revolution. With his strong dislike for the impact of industrialization on what he regarded as faithful peasant life, Vincent responded by appropriating

this stagnancy creates just the sort of realm of pleasant distraction from the world that many appreciators seek in art.

Another type of recognizability in art is stylistic consistency. For example, a cubist portrait by Pablo Picasso may not resemble the sitter but it does look like a "Picasso." This stylistic conformity, which is called a "signature style," becomes a surrogate subject matter, in which artists themselves

Impressionism's individualized brushstroke and personalizing it. Vincent, who signed his paintings with his first name, endowed each brush mark with an existential weight, not of the fleeting perception of optical light but the permanent solidity of spiritual presence. However, by the end of the nineteenth century, Impressionism had become a formulaic "style." Nevertheless, divorced from the circumstances that gave meaning to that method of painting as a materialized strategy of seeing, some painters continue to dab away at their canvases.

Guy Chase's art not only avoids "style," in cases such as his *plein air* paintings of cemeteries, but he also comments on the dead-end result of the continued conflation, in the imagination of many viewers and artists alike, of "art" and "style." It should be added that Chase's wit has not been directed only at the "amateur." He also holds the art world's initiated elite as equally suspect. Chase's cemetery paintings were first created, in 1986, at a time when terms like "the death of painting" were often heard in artistic circles. Looking at these cemetery paintings, one senses Chase turning these theories against themselves. By making paintings that, without an apparent sense of irony, embrace and neutralize the concept of their own death, these works demonstrate that painting will, in fact, never die.

In distinguishing between the "artistic method" and "artistic style," it should be further noted that, while "artistic methods" respond to certain historical circumstances that demand that the artist propose new methods of working

and seeing, the moral urgency of these "artistic methods" is that they call new strategies of seeing into being. By proposing new ways of looking at the world, this art may also change the way in which we live in the world. As such, these works of art call the viewer to a new way of being, not complacently accepting the world as it is inherited but rather participating in the acts

MONTROSE CEMETERY: LOOKING NORTH, SITTING ON URSALA HIRSCHBRUNER
1986
ACRYLIC
13" x 9"

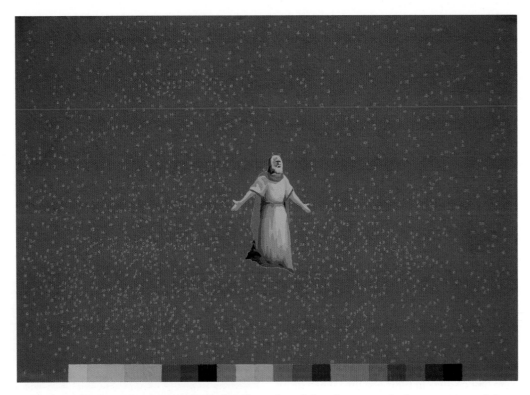

**DELUGE
(21 COLOR OIL
PAINT-BY-
NUMBER)**
1990
OIL ON
PAPERBOARD
10″ x 14″

of the sanctification of creation that God is doing in and around us. Yet this existential critique is not often what the art appreciator seeks when they look at art.

The second cardinal rule of art appreciation is that art should reaffirm what the viewer already thinks or believes. Guy Chase encountered this paradigm of art criticism when he joined CIVA. As a social network for artists dedicated to religiously oriented art, CIVA helps Christians with artistic interests to find opportunities to show their work in a safe and uncritical environment. Still, as he began to exhibit in CIVA, Chase

found that his art, with the exception of those works with more explicitly religious titles and texts, generated suspicion. The crux of this tension is the question, "What makes a work of art authentically 'Christian'?" The "Christian" authenticity of Chase's work was often questioned because, instead of relying on subject matter, his art depended on such elements as content, form, and process in order to communicate. For Chase, what makes a work of art "Christian" is that the art object is honest about the artist's own personal encounter with God.

The problem, particularly as applied to

sacred art, with the demand for an art of spiritual reassurance is that it suggests a relationship with God that is not entirely biblical. For example, in the story of Noah, God called him to build a giant sea vessel. Noah faithfully complied without assurance that God had a plan. Nevertheless, Noah was still human; he must have had doubts. In *Deluge*, Chase shows the figure of Noah surrounded by a universe of numbers. His posture is one of supplication before God while his lack of comprehension is evident. Noah's faithfulness isn't a fruit of knowing; it is a fruit of faith.

Deluge is based on a paint-by-number kit. The paint-by-number process is one that requires the painter to faithfully follow instructions. In *Deluge*, Chase followed these received designs in painting the figure of Noah, but the rest of the painting is modified. Chase mixed the 21 colors of the kit, each individually designated across the painting's lower edge, and then painted each area of the paint-by-numbers painting individually, leaving the numbers revealed. Thus, in the painting's very process, *Deluge* is a devotional work that balances, or unites, aspects of free will and determinism. The paint-by-number kit Chase chose is prescriptive and limiting; for example, it contains 21 colors, which he did not choose. Chase both embraces the limits of this kit but also applies his own creativity to them. The end result is a painting that, in its visual form, explores and exposes the very structure of the paint-by-number kit. This form, and the process manifested in the form, is not independent of *Deluge*'s invisible content: the

theme of faithfulness. (The subject matters of *Deluge* are Noah and the paint-by-number kit itself.) In *Deluge*, the content, form, and process are indistinguishable. This makes *Deluge* both a great work of art and a direct challenge to the presuppositions of religious-art appreciation.

Chase's art-making process is one of looking for and listening to God. This is a course of creativity that is deeply dependent on the movement of the Holy Spirit. In some ways, this reliance on God's inspiration may seem antithetical to some of our customary assumptions about artistic creativity. Still, Chase's method is faithful to an understanding of his own artistic talents as being a gift from God. Every work of art is an attempt to respond to that continuing mystery. Nevertheless, Chase found that many art-appreciating Christians did not want mystery in their faith and/or art experiences.

Perhaps his refusal to conform to expectations is the greatest conceptual and visual strength of Chase's art. At the same time, Chase means for his work to be accessible to the widest possible audience. To that end, this book brings together four essays that each consider Guy Chase's art from different points of view. Joel Sheesley, himself a painter, establishes the historical context and conceptual method of Chase as a painter. Artist Ted Prescott explores the process and purpose of Chase's art. Art historian Wayne Roosa examines specific relationships between Chase's work and art history. Artist Albert Pedulla situates Chase's art within a contemporary dialogue about what it means to be a "realist."

In the interview at the back of this book, Guy Chase describes himself as a painter. This is a more meaningful and loaded assertion than might be initially evident. As an artist in graduate school, at the School of the Art Institute of Chicago in the late 1970s and early 1980s, Chase came to maturity at a moment when the medium of painting was considered by many in the contemporary art world to be exhausted. In fact, the literal nature of Chase's painting on book pages recognizes that the pictorialist presuppositions that had guided painting since the early Renaissance no longer held currency.

Sheesley traces Guy Chase's artistic maturation, beginning with his graduation from Bethel College in 1977. In the late 1970s, many contemporary artists were rethinking their commitment to the seemingly spent medium of painting. Yet, some painters, such as Chase, remained committed to painting while recognizing the conceptual challenges of being a painter. Some of these issues were articulated in an essay by Marcia Hafif, "Beginning Again," published in the September 1978 issue of *Artforum*. Hafif wrote bluntly, "The options open to painting in the recent past appeared to be extremely limited." As Sheesley noted, this "precipitated a minor crisis in which the question of authenticity" became crucial for Chase. Yet, this problem seemed to Chase to also contain its own possible solution. By embracing painting's limitations and applying a reductive process, Chase explored the possibly of deconstructing his painting to its most basic elements: the quality of the materials, and the quality of the artist's attention to both observation and technique.

As Chase took stock of his art, this reductive method had both artistic or practical use and fit Chase's spiritual or devotional personality. Whereas Hafif's focus was principally conceptual and her solution formalist, Chase was drawn to her proposal because it matched his personal faith life. As he applied painting as a meditative process of "paying attention," it became a search for where God is by exploring possible places where He is not. In the interview at the end of this book, Chase describes this pursuit in terms of posing a prayerful question:

> Okay God. Sure, you are there in the obvious sacredness of gold and white and blue and red and black, in the triptych, the altarpiece. Will you present yourself in pastel? Will you present yourself in the legal pad? Will you be there if I include a smiley face? What about paint-by-number paintings? Or, if the process is sufficiently meditative, quiet and consistent, surely you will be there. It is easy to pray in the closet, to listen and be present. But what about those noisy moments when the mundane of life gets in the way?

This is the positive power of negative, or reductive, thinking.

Guy Chase's reductive strategy is successful because he is skeptical without being cynical. He embraces an apophatic theology in which God is sought in "negative" terms. Recognizing the limitations of our language, this method

questions if we can sufficiently understand concepts such as goodness, truth, and beauty in order to properly apply them to God. As his artistic practice is informed by faith experience, Chase faithfully reduces his art (he reduces the visual imagery, the materials, and his own activity) to its essence.

Sheesley situates Guy Chase in relationship to other contemporary artists such as Richard Tuttle, Robert Gober, Rachel Whiteread, and Charles Ray. These artists share Chase's method, which is formally reductive and conceptually expansionist. Works of art such as Charles Ray's 1997 *Unpainted Sculpture* demand that we focus our vision and pay attention to details.

In making *Unpainted Sculpture*, Ray purchased a wrecked Pontiac Grand Am from a salvage auction. This automobile had evidently been in a horrible accident. In a two-year process, Ray dismantled the car, cast each piece in fiberglass and reassembled them as a sculpture. While *Unpainted Sculpture* raises many questions, one wonders what Ray aimed to accomplish that could not have been accomplished by casting the car as one single piece. It may be that Ray means for the viewer to contemplate the relationship between the parts and the whole. What role does each part play in the structure and process of the sculpture? Do we, as individual persons, have meaning in any broader structure or design? In thinking about these questions, does our understanding of *Unpainted Sculpture* change with the revelation of special knowledge of the creator's designs and methods? It is possible that simply looking

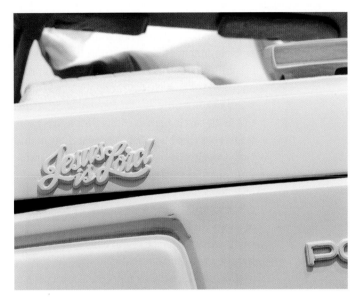

at *Unpainted Sculpture* is not enough to know it; some of its method and meaning are intentionally concealed within it.

According to the artist, he chose this particular car in part because it had been in a fatal accident. Ray didn't say who or how many persons had died in this car, but the wreckage itself certainly provokes the imagination. This added knowledge returns us again to the question of design. Is there a design to life—a design that can be called true, good, and beautiful—in which this sort of carnage finds meaning? In painstakingly and devotedly making a work that seems, at least initially, pretty meaningless to most viewers, Ray creates a work that is, in the very process of its making, a metaphor for profound questions about the human condition.

Many visitors to the Walker Art Center in

**UNPAINTED
SCULPTURE** detail
CHARLES RAY
FIBERGLASS, PAINT
1997
60" x 78" x 171"

See page 19 for
collection details.

Minneapolis, where *Unpainted Sculpture* rests, will not look carefully enough to notice the car emblem attached to the rear trunk. It reads, "Jesus is Lord." Although the original emblem was probably made of faux chrome and meant to visually stand out from the car, in *Unpainted Sculpture*, this text is cast in the same fiberglass and is nearly invisible. One has to look very carefully to find God. Does the discovery of these words transform our understanding of this chariot of death? Like many elements of *Unpainted Sculpture*, this declaration of Christ's sovereignty can be read in several different ways. It does remind us that God's will can often be found where and how we least expect to find it revealed.

Unpainted Sculpture's conceptual pivot point is the contradiction that, given the car's history, the art object is a visual record of lived experience. The car came off the assembly line in "perfect" shape. The shape or form we see in the sculpture is the result of an accident-prone life and a life-taking process. The art of Guy Chase, from his early watercolor paintings to the book-page paintings to his series *Must Love Life*, are works that, in each case, developed from the twists and turns of Chase's life. The sacred content of Chase's art has the potential to transform even the most tragic aspects of the human condition.

For example in his 2009 series *Must Love Life,* Chase draws on his experience as a man in his fifties, after the end of his marriage. This work, which appropriates images from the dating website Match.com, both sensitively acknowledges the deep personal pain of this experience, the sense of rejection and shame, and

humorously examines the lengths to which we go to project an image of ourselves as perfectly happy. In making this series of work, Chase found that many Match.com profiles listed "honesty" as a desirable quality in a match. It is the honesty of Chase's art that gives it compelling resonance.

Ted Prescott examines the devotional nature of Chase's art, both that it is born of a method of quiet and expectant abiding and requires

**MUST LOVE
LIFE #10**
2009
LASER PRINT
ON CRAFT
PAPER WITH
JUTE HANDLE
15" x 10"

THE ART OF **GUY CHASE**

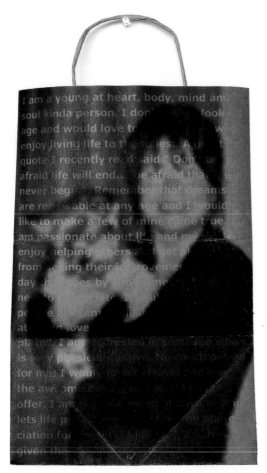

(*popt—stop fuming*), we see Chase making his religious and artistic inheritance his own.

Prescott argues that Chase's art is "Christian" in its method and substance rather than in its subjects and surface. He quotes Chase as saying, "I work, expecting, waiting, listening, hoping for some connection, for some revelation, some divine intervention, some evidence of logos incarnate." Yet this incarnation is not evidenced in the type of overtly religious image, such as a picture of Jesus, that some viewers might expect or demand in a "devotional" work. Prescott distinguishes between art with "Christian content" and art with "Christian intent." Intent is tied to the communication of a message; in this method, the work of art is a messaging device to communicate a religious message. Content is a state of being. A work of art is not *about* anything; it *is* something. Chase's paint-by number paintings are not about humor; they are humorous. They are not about devotion; they are devotional. Thus, Chase's art can be an active, even prophetic, agent of grace in the world in a way that no illustration about faith ever could be.

The conceptual and visual strength of Chase's art rises in part from his connections to the rich history of art. In his essay, Dr. Wayne Roosa builds on the already established processes and purposes of Chase's art to examine the historical resources at Chase's disposal and, specifically, how Chase employs these resources. Looking at his relationship with artistic influences ranging from Russian icons to Gustave Courbet to Kazimir Malevich to Ad Reinhardt to Agnes Martin, Roosa details how Chase

the same of the viewer. Prescott considers some of the personal tools and methods that Chase brings to his art. He traces some of the processes by which Chase's art was both influenced by and became a means of working though the issues of his evangelical background and artistic education. This history brought Guy Chase to a series of works painted directly on the pages of Norman Vincent Peale's book *The Power of Positive Thinking*. In works such as *Untitled*

MUST LOVE
LIFE #1
2009
LASER PRINT
ON CRAFT
PAPER WITH
JUTE HANDLE
15" x 10"

UNTITLED

(MAJESTY ICON)

2009

GOUACHE ON

ICON BOOK PAGE

11" x 8.5"

has repeatedly employed the history of art as something foundational to his own work. For example, Chase has done a series of works in which he has literally taken images of Russian icons from the pages of art history textbooks and painted his own abstract forms over them.

What is equally important to Chase's knowledge of art history is the degree of self-criticality he brings to his appropriation of art history. Chase seems to recognize that the influence of history is inevitable and therefore he embraces it wholeheartedly. For example, in his appropriation of images of icons, he selects images from history textbooks. Thus he makes the medium of his connection to the icons evident, inviting

us as viewers to consider how our own understanding of the history of Christianity and the visual arts is shaped by the media through which we encounter them. As Roosa's essay examines the influence of these historical sources on Chase's creative production, it also becomes evident that, as does all good art, Chase's creative use of these sources transforms or expands our understanding of them. Thus, Chase's relationship with art history is dialectical; his work is not only grounded in history, but history is continually revived by this use.

Whereas Roosa establishes Chase's links with history, Albert Pedulla describes the significance of Chase's break with a pictorial conception of painting that had maintained a monopoly on Western painting since the early Renaissance. Contrasting pictorialist and non-pictorialist paintings of the American flag, by Emanuel Leutze and Jasper Johns respectively, Pedulla situates Chase's paintings, such as *Untitled* (*Stripes and Ducks*), within a contemporary paradigm of literal realism. Pedulla points out how this process, instead of diminishing "art," in fact elevates the mundane and marginalized by revealing their inherent beauty and value.

Having examined the historical context out of which Chase's art was born, the processes by which it matured, the art history from which it was nourished, and its conceptual innovation, there still remains one short but critical question: "So what?" What is at stake in Guy Chase's art that gives it any sort of urgency or currency? The sincerity of Chase's motivations, the dedication of his craft, the cleverness of his wit, the

originality of his creativity, the visual interest of his work—these may each or all distinguish Chase's art from much of what is passed off as "art," but these are, at least for me, not enough. If I may be self-reflective, my own interest in this project stemmed from what I regarded as a nearly unique quality in Guy Chase's work as an artist of faith. It seems to me that Chase is one of the few artists of faith from his generation to understand intuitively that a painting is not just a pretty picture or a visual expression of faith. A work of "art" is an image, or object, that materializes a method of seeing.

The importance of Guy Chase's art is, at least, two-fold. His art challenges the viewer to reconsider how they see the world. Do we really pay attention? Do we really seek God? Do we only look for evidence of Him where it is obvious and convenient for Him to be? At the same time, Guy Chase's art challenges every artist of faith to dedicate themselves to their work as an act of listening and devotion.

What distinguishes Chase, both as a person and an artist, is the gentleness and humor in which he sheaths his critique. This is, in large part, because his work is, first and foremost, addressed to himself. The process of creating his art has made Chase increasingly aware of his personal (artistic and spiritual) limitations. Thus his practice has developed from a pursuit of humility, of prayerful waiting and listening. Chase's oeuvre is a model of artistic and spiritual faithfulness. Because his work is devotional, a visual manifestation of him drawing closer to God, Chase is interested in both addressing

his audience and in their response. He notes, "When or if this [connection to God] happens, a power beyond me presents itself, beauty presents itself. Then, I do feel a duty to exhibit the work for other people, in case they are in the same place as me." Since Chase's art is an offering first to God and then to his audience, this book is likewise. Finally, this book is a gift of thanks to Guy Chase for his art.

ENDNOTES
1 Beginning in 1994, the artist team of Vitaly Komar and Alex Melamid conducted a series of public surveys in several different countries. Based on these survey results, they produced a series of "most wanted" and "least wanted" paintings for each country. The "most wanted" paintings were, mostly, tranquil landscapes with trees, lakes, mountains, animals, children, and (in two cases) Jesus.

HER INTIMIDATING INTELLECT LEAD TO A PREFERENCE FOR SACRIFICE OVER GRACE
2010
OIL AND ACRYLIC WITH INKJET PRINT ON CANVAS ADHERED TO BIRCH PANEL
23.5" x 19"

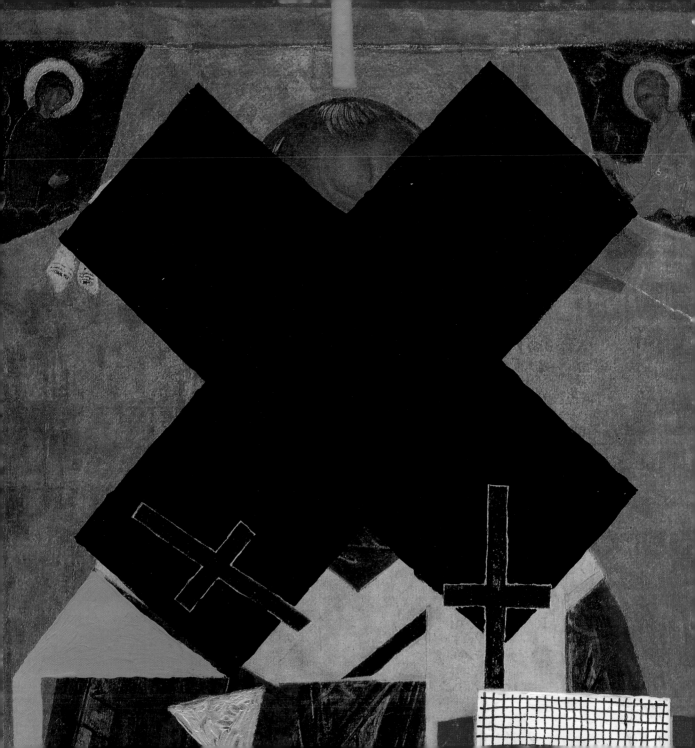

"Many poets are not poets for the same reason that many religious men are not saints: they never succeed in being themselves. They never get around to being the particular poet or the particular monk they are intended to be by God. They never become the man or the artist who is called for by all the circumstances of their individual lives."
—Thomas Merton

Guy Chase represents the inverse of Merton's picture of the failed artist/saint. The process of *becoming* that Merton chronicled so well throughout his writing life, the integrity of which was so important, Chase has sensed intuitively and grasped in a relentless clutch. Becoming the artist called for by all the circumstances of his individual life is something that Chase has consciously and actively pursued on personal, artistic, and spiritual levels. Merton's negative picture, however, is useful, as it shows us just what such an accomplishment involves. As Merton articulates, this is not simply a matter of being oneself, though it is nothing less than that. It is also a matter of understanding one's self as a theological being, understanding one's self in relation to God. But then further, it is recognizing as well that the particularity of one's identity is situated within a set of historical conditions or circumstances to which one owes a response. So conceived, an artist's or saint's identity is an interweaving of self, God, and the historical and practical realities that break around him or her.

Merton characterizes the person who submits to such an integrated development as a *humble* person. In a chapter titled "Integrity" in *New Seeds of Contemplation*, Merton develops the idea that humility and integrity are coincident qualities: "It is not humility to insist on being someone that you are not."[1] In an age where the image of an artist (or even of a saint) already could float above the heads of the crowd as a kind of spectacle inducing an imitative sycophancy, Merton called the would-be saint or artist back to that person's own basic realities. It is from within these realities, and not above them, that integrity is born. Such humility, based on a dogged pursuit of one's essential situation, is the perfect characterization of Guy Chase's artistic career.

The discovery of that integrity, that point at which self, God, and one's historical circumstances might be integrated, became a natural quest as Chase went about his artistic education. After graduating as an art major in 1977 from Bethel College in St. Paul, Minnesota, and having completed the normal round of looking at and sampling the broad field of artistic

OPPOSITE
**UNTITLED
(ST. NICHOLAS
BLACK X ICON)**
2009
GOUACHE AND
INK ON ICON
BOOK PAGE
11″ x 8.5″

activity such an education entails, Chase identified with a kind of abstract painting derived from the intuited geometry of the work of Richard Diebenkorn. At the same time he found himself back in his native California attending a Berkeley MFA show where all the diverse work in the exhibition appealed to him with equal intensity. This precipitated a minor crisis in which the question of authenticity reared its head. "But what would be authentically mine?" he found himself asking. That question would be at the core of Chase's own MFA studies that ensued directly at the School of the Art Institute of Chicago.

Instrumental in addressing this question was an essay Chase read by Marcia Hafif, titled "Beginning Again" and published in *Artforum* in 1978. The essay chronicles the search for a material and conceptual basis for art-making located in an artistic process that became very important to the generation of artists following Abstract Expressionism who did not join one of the many streams that flowed out of Pop Art or contemporary Realism. In the essay, Hafif worked through the problems facing painters at that time and outlined a rough strategy for how to move forward. Hafif described the situation as follows:

The options open to painting in the recent past appeared to be extremely limited. It was not that everything had been done, but rather that the impulses to create which had functioned in the past were no longer urgent or even meaningful. Tracing magic images, storytelling, reporting, representing in a one-to-one relationship a scene or figure in paint – none of these acts was credible in the way it once had been. Abstraction appeared to be used up; expression through shape and color was very familiar and had become meaningless. The process of flattening out the canvas had reached an end; formalist painting had soaked color into the canvas and moved shape to the edge, presenting an almost but not quite, unbroken field. We no longer believed in the transcendency of paint and saw little reason to use the medium of painting for making art.[2]

This lack of credulity and meaningfulness that Hafif found in recent painting tradition was an insight not shared by a significant number of other artists at the time. The same artistic ethos that Hafif lamented as bankrupt nurtured the advance of various types of artistic realism, and the rise in both Europe and America of what would become known as Neo-Expressionism led by artists as diverse as Anselm Kiefer, Julian Schnabel, and Sandro Chia. For these artists and others, transcendent paint, storytelling, and "one-to-one" representation remained vital and urgent creative stimuli.

But Hafif's outlook did represent another vein of artistic sensibility, one that emphasized a more objectivist and analytic response to aesthetic culture. Hafif relied on her encyclopedic

knowledge and research of the history of painting techniques and exhibition tradition to hammer out a more believable reason to go on painting, or rather to begin to paint again: "It was necessary to turn inward to the means of art, the materials and techniques with which art is made. Artists still interested in painting began an analysis—or deconstruction—of painting, turning to the basic question of what painting is, not so much for the purpose of defining it as to be able to vivify it by beginning all over again."[3] Looking reductively at "what painting is" offered a sense of relief from the more idealist overtones of the emerging expressionists on the one hand and the realists on the other.

This objectivist and pragmatic starting point appealed to Guy Chase intellectually, and as a somewhat instinctual approach to life itself. Chase tells a story about himself that demonstrates how a penchant for a diagnostic outlook infused his approach to the most routine duties. From 1977 through 1979 Chase picked up an odd job as a groundskeeper for a local school district. He found himself sitting on a lawn tractor for extended hours working his way up and down patterns of mown grass. His thoughts turned toward the nature of his task. What were its practical components? How could he do it purposefully? What was the meaning of it? How could he honor God in the work he was doing? Ideals here seemed remote.

Chase took stock of his context and working materials: he had his lawn mower with fixed cutting width, a specific shape or area of grass to mow, and a requisite efficiency of execution.

He saw himself moving back and forth across a limited space defining and redefining it by the cut edge of grass. From an aesthetic standpoint, the field, initially a consistent whole, was first divided into cut and uncut areas of grass, which then gradually returned to wholeness as the

entire space was eventually trimmed and thus unified as grass of uniform length. On the practical level, he reasoned that doing the job carefully was a concrete service to the students and staff at the school. He also found that the prescribed repetitive action, moving from wholeness to division and back to wholeness, became a matrix for meditation. It was conducive to devotional reflection; it became a form of prayer.

Maintaining and holding at a high level this mix of practical, aesthetic, and devotional value required formatting the project in terms of a set of rules. The rules had to be respected, and the project had to be conceived and executed at a high level of consciousness and carried out in an orderly manner. In the realm of lawn mowing, such rules verge on obsessive-compulsive.

Transferred to the process of making art, however, such awareness of the potential of one's actions and material context seems more reasonable. Hafif, in her inward turning to the materials and techniques with which art is made, strategized in this way:

> The work is determined through the observation of the materials and techniques chosen for a given project or body of work. . . . The qualities of the materials and tools, and also the nature of the discipline, determine the choices made. Rules emerge derived from the material and methods in question, and results become the desired end product. . . . With this integrity even the smallest decisions take on great impor-

tance, as an interrelated consistency is produced among all the elements of the work creating a meaning.[4]

The group of artists for whom such an approach played some part in their creative processes are generally considered conceptual, minimalist, and with a tendency toward abstraction. Hafif traces the lineage of this sensibility back through such artists as Vasily Kandinsky, Kazimir Malevich, the "Unism" of Wladyslaw Strzeminsky, the De Stijl artists, and painters like Ralph Humphrey, Robert Ryman, Brice Marden, Ad Reinhardt, and others. Their concerns were for the process of painting itself, for an understanding of the painting as a unitary object, and the arcane spiritual quality that emerges from a rigorously disciplined methodology. This conceptual orientation is not far from Chase's approach to lawn mowing.

But the point of the lawn-mowing story is that it gives us a partial view into the mind of Guy Chase. Ryman, Marden, Reinhardt, Agnes Martin—all these artists are important to Chase, but they do not at all fully predict the nature of his work. That is because Chase's work does not arise solely out of the formalist experience and thinking of other artists. In fact, rather than serving as influences on Chase's work, these formalist artists provide instead a confirmation of the intelligence of the artistic framework into which Chase interjects observations derived from the much more unstructured realm of lived experience. The strategy that Marcia Hafif outlined made sense to Chase even if limiting its

application to a strictly formalist art production did not. It is Chase's rootedness in life itself that, when articulated in formal artistic terms, gives his work its surprising luminosity.

To get at this luminosity, we must enter into what may be called the humor of Guy Chase, or his temperament. Chase has the potential to be funny, and he sometimes flirts with that potential. But, in fact, Guy Chase's humor, the overall ethos out of which he creates, is rather serious. It is serious about the humdrum things that surround everyday life, things that at first glance don't seem capable of supporting serious attention. He takes things seriously that others would not. His subject matter and the materials of his art are invariably drawn from the most pedestrian of life encounters and personal experiences. Guy Chase makes art using rolls of paper towels, or coffee-stained paper placemats, or the inside of flattened aluminum soda cans. What can we think when an artist exhibits laboriously traced sheet after sheet of graph paper, who makes paintings that look like yellow sheets from legal pads, or who paints on Sudoku puzzles?)

As disbelief mounts, one might suspect a wry joke is brewing. But it isn't. Chase exerts a great deal of energy over unsuspecting humble subjects and materials. Like the work of the sculptor Richard Tuttle, Chase creates in a humor or temperament that recognizes and acknowledges the subtleties of the ephemeral *as* ephemeral. Tuttle, who grafts bits and pieces of everyday materials into unassuming artistic constructions, is sometimes referred to as

takes on a humble task, but one that has evocative, even provocative consequences.

The metaphorical transition from humble material to grand work of art can be disarming, especially when, as in Chase's work, this transition does not materialize in or seem to be located in a traditionally recognized kind of craftsmanship. Here we do not encounter bravura drawing and brushstrokes. What we end up perceiving is not the grandness of handicraft demonstrated in Chase's having traced over sheet after sheet of blue graph-paper grid lines with white correction fluid, but rather the laborious difficulty of the task. We recognize that we are confronting a kind of anti-aesthetic, an inversion of our aesthetic expectations.

The work takes on a didactic property. There is something instructional about Chase's visual poetic. Chase's tracing over grid lines is both an eradication and substantiation of their pervasive power as the veil through which Western culture has both received and perceived its awareness of the world. Grids of different kinds have been the means for the division and measurement of visual perception and for the visualization, through graphing, of elusive abstract data. They are also, in themselves, a kind of mandala, or then again, abstract decorative constructions. Chase seems to want us to ponder this. We are also aware that the grid Chase has labored over is like a field of grass that, in mowing, he has defined and redefined, dividing and returning to wholeness.

That movement from division to wholeness is constantly at work in Chase's art. In his

a postminimalist. The esoteric framework of minimalism is maintained, but the work itself is constructed using fragments of quotidian everyday materials. Like Tuttle, Chase's work generates a tension between a sense of humility and arrogance. Like Sherry Levine, who has exhibited her own photographs of the photographic work of other photographers, Chase

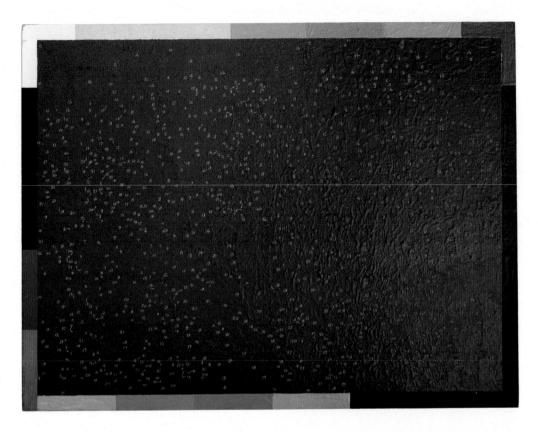

OPPOSITE
**JONATHAN
EDWARDS'
NOTEPAD**
GOUACHE
ON PAPER
1989
11″ x 9″

**UNTITLED
GREY FIELD
(21 COLOR, OIL,
PAINT-BY-
NUMBER)**
1990
OIL ON PAPER
BOARD
12″ x 16″

twenty-one-panel project titled *Actual Things with Their Own Colors* (1999), Chase deconstructed a paint-by-number picture depicting a couple of hunting dogs. To make the work, he excerpted from the numbered diagram surface of the paint-by-number panel a set of outlined color shapes prescribed for a color from one of each of the twenty-one colors accompanying the paint-by-number set. Each shape was then enlarged and became one of a set of independent, variously shaped monochrome paintings.

But having broken this world into pieces, Chase also exhibited the original paint-by-number panel that acts as a key through which all the pieces can be seen to fit together within a larger context. The project title, *Actual Things with their Own Color*, reminds us that each seemingly abstract unit is also an actual thing, a piece of reality that is part of a whole.

In *Untitled (grey field)*, (1990), also based on a paint-by-number panel, Chase painted in grey around all but the blue numbers on most of the

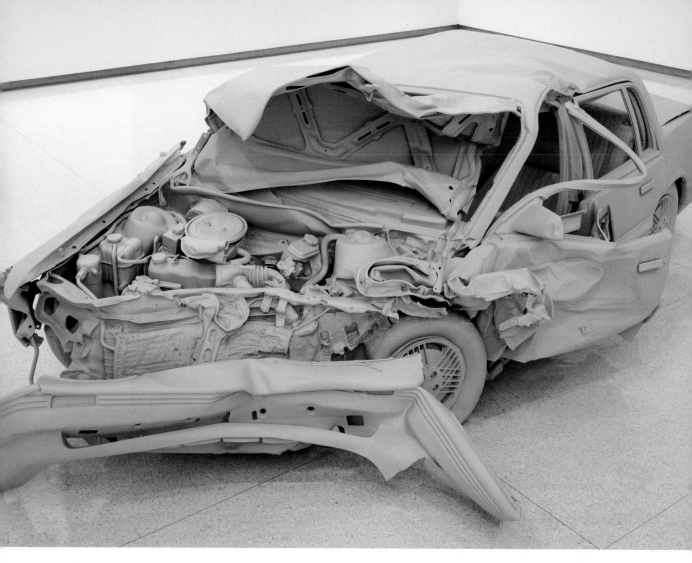

panel, and used what one supposes were the remaining colors of the kit to create a multi-colored framing margin around the exterior of the piece. Here, all the divisions of color intended through the numbered and outlined shapes are lost. We are left with the unity of a monochrome grey that supports the likewise-uniform blue color of the numbers. Through a painstaking and methodical painting process, the complex order of the paint-by-number panel has been disassembled and then returned to a new unity.

Such division, revision, and reconstruction

can also be understood as disfigurement, and this is heightened when Guy Chase takes religious images and texts as his starting point. The painter Eric Fischl remarked some years ago that religion has become one of the taboo subjects for contemporary artists. Andres Serrano generated enormous antagonism in the religious community when he exhibited a photograph titled *Piss Christ*, because the photograph was perceived by many in the faith community to disparage belief. The secular art world, on the other hand, is typically very ill at ease with art works that affirm belief. Art historian and critic James Elkins's book *On the Strange Place of Religion in Contemporary Art* traces the decline of serious religious art and speculates its almost inimical relationship to contemporary art. Chase, nonetheless, has chosen to take religious belief head-on as a problematic yet insistent, enduring presence to be reckoned with.

Intermittently from the 1990s, Chase has used reproductions of religious icon paintings as a starting point for his work. His paintings that reproduce portions of biblical Scripture date from the 1980s. An examination of these works helps further locate Guy Chase within a specific bloc of contemporary artistic dialogue and understand him as an artist working within the framework of Christian belief. To set up the nature of this dialogue, let us consider an artwork by another prominent contemporary artist, Charles Ray.

In 2007, Ray completed a work titled *Hinoki*. The sculpture, about twenty feet long, now fills a rather large room in the Modern Wing of the Art Institute in Chicago. Carved in Japanese cypress wood, it is a sculptural representation of a large, hollow, fallen log Ray found in California. He wanted to address his sense of the breath of life represented in this great old log. He had it cut into sections and hauled to his studio, had molds made from them, and then reconstructed a fiberglass version of the log, which he sent to Osaka, Japan, where master woodcarver Yuboku Mukoyoshi and his apprentices carved the tree in cypress wood. Ray conceived the project as carved from the inside out.

The work as we behold it is as much a monument to a process of artistic interpretation as it is to the tree itself. Though the inspiration for the work was the tree Ray found in a field, the work as completed does not point back to the circumstances of that tree. Instead it provokes questions about our perceptions and how the translation or realization of those perceptions in material form actually blocks out aspects of the reality upon which those perceptions were founded. Though the wood itself is perishable, nothing about the carved, clean cypress speaks of rot and decay, or even suggests the past life of the tree itself. What we confront is an astonishingly immaculate, labor-intensive carving that copies the form and surface of a fallen tree. The tree is now a work of culture rather than nature. Like Ray's *Unpainted Sculpture* (1997), a meticulous fiberglass copy of a smashed Pontiac Grand Am that is no longer a "car," the "tree" is no longer a tree. It represents its own representational process. It obscures its referent even as it identifies it.

OPPOSITE

UNPAINTED

SCULPTURE

CHARLES RAY

1997

FIBERGLASS, PAINT

60 x 78 x 171"

From the collection of the Walker Art Center, Minneapolis. A gift of Bruce and Martha Atwater, Ann and Barrie Birks, Dolly Fiterman, Erwin and Miriam Kelen, Larry Perlman and Linda Peterson Perlman, Harriet and Edson Spencer with additional funds from T.B. Walker Acquisition Fund, 1998.

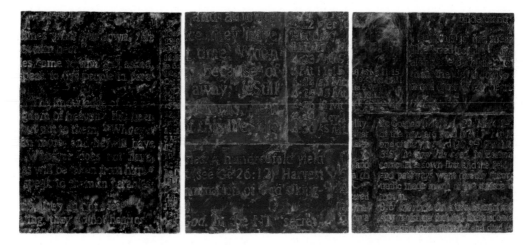

It may be that for Guy Chase, biblical Scriptures are inspirational in the way the old fallen log was for Charles Ray. Chase seems to perceive a "breath" in them. He holds them in high regard and is committed to them. But he also realizes that as we receive them and reify them, they are transformed into products of contemporary culture, products that suit our own current needs. Chase's 1995 work *Hermes Blues (triptych)*, is a painting consisting of three monochrome panels that depict passages of Scripture that tell Jesus' parable of different soils and how they each receive seed to different effects. Each panel contains a different closely cropped section of this parable as seen on a biblical page including footnotes, cross references, and commentary. The title *Hermes' Blues* refers to the root of the word *hermeneutic,* derived from the messenger, Hermes, and to the fact that each monochrome panel is painted a different blue.

The three paintings of the triptych themselves have the physical presence of small tablets (16" x 24" x 1"), and this gives a kind of corporeality to the text. But each panel in the triptych presents only a snippet of different parts of the parable of the soils, so there is also a sense that we are looking at something like Dead Sea Scrolls fragments, which suggests fragility and a wholeness that has been lost and now must be reconstructed. There is also the complication that, although these are paintings, they are images of text. It is as if the *pure word* has been entangled in the physical ambiguity of paint (or is it the ambiguity of words?). It has been enfleshed. It is no surprise that earlier, in a similar Scripture-based painting from 1987, *Abstract Painting (Jn.1)*, Chase already had addressed the conundrum that the word had become flesh. Collectively, these paintings suggest that a singular final interpretation of the Scriptures is unfeasible. They represent the

HERMES' BLUES

1995

WATER COLOR

AND ACRYLIC

ON PANEL

EACH PANEL

24" x 16"

difficulty of interpretation as much as they represent their subject, Scripture itself. Scripture, like Charles Ray's *Hinoki*, has in the end been replaced in the process of being represented.

The late twentieth century was marked by hermeneutical debate, and given the process-oriented conceptual framework out of which Chase works, it was almost predetermined that he would engage hermeneutical questions. Given his religious commitments, it is natural that this hermeneutical interest would be directed toward the Bible. In *All the Highlights* (1997) and *Just the Highlights* (1997), Chase addresses the phenomenon of highlighting text with transparent markers. The format of these paintings suggests that a translation of a chosen biblical text, with its notes and cross-references, is the subject represented. But in these paintings only the layout or format of the pages is discernible because only the highlighting shows up;

ALL THE
HIGHLIGHTS
1997
GOUACHE
ON PAPER
22" x 30"

there is no text visible. Highlighting any portion of a text makes other portions seem unimportant. In a biblical text, where the presumption is that all portions of the text are sacred, nothing is unimportant. Therefore everything must be highlighted. But when everything is highlighted, everything is also obscured. Again, the interpretative task is clouded.

Guy Chase, as a man of his own time, has enjoined the postmodern interrogation of traditional concepts of interpretation. But he has not joined the inquest as a cynic; he does not despair; the questioning has not led him to doubt the possibility of meaning. Rather, it has led him to hold meaning differently.

In 1978, Marcia Hafif set out a pragmatic strategy for "beginning again." The artists most closely associated with her strategy were formalists. In ensuing years that same analytic pragmatism began to figure in the work of other artists like Sherry Levine, Richard Tuttle, Charles Ray, Robert Gober, Tony Cragg, and Rachel Whiteread. These artists looked through the pragmatic crosshairs and out into the world. They wished, it seems, to begin again in the realm of real experience, or as in Guy Chase's title, the realm of "actual things." To begin with actual things rather than with ideals can suggest, in the hands of some, an excoriating doubt or disbelief in transcendent meaning. But it also, in the hands of others, has led to an awareness of a spiritual dimension active within actual things.

A most revealing instance of the discovery of the spiritual dimension within actual things is told in Guy Chase's own words in an excerpt from a short essay titled "Affirming Abstraction," written for the Christians in the Visual Arts newsletter in 1998:

> I asked my students to bring to class things for "show and tell" that they thought were meaningless. Then I proceeded to discuss the meanings I found in their objects to illustrate that content is always available. One student pinned an empty, plastic bag to the bulletin board. I proceeded to interpret meaning from the plastic bag until she stopped me. It wasn't the bag that was meaningless but that which was inside the bag. I thought for a moment about Jeff Koon's plexi-glass cases containing brand new wet-dry vacuum cleaners. Was I confronting a vacuum in which nothing exists? And then I realized; if God is everywhere and there is nothing inside the bag, then the bag must contain only God. I can't believe I am telling you that a zip-lock baggie became for me, at that moment, a work of art, a thing of beauty and truth. I was inspired, perhaps, by God in the bag. I discovered that the most minimal work of art provides an opportunity to recognize God's presence; an opportunity, that is, to be quiet and listen.

There are some artists for whom Marcia Hafif's call to "begin again" never registered because they never felt obliged to stop in the first place. For some who did hear that call,

beginning again meant beginning in a vacuum, negating past ideals, negating the possibility of God. Guy Chase represents a rare form of pioneer for whom beginning again has meant the discovery of God within the vacuum. The authenticity of his discovery has depended on two things: his awareness of and participation in the artistic questions and dialogue of his time, and his discovery, within the circumstances of his own experience, of a means to prove the merit of that dialog. There is a sense in which Chase's religious belief has been as much at hand and available as subject matter for his work as have been paint-by-number sets, Sudoku puzzles, or legal pads and graph paper. It has been through a concentration on his own circumstances, through the closeness of his chosen subject matter, that his explorations of broader artistic questions have found their proving ground.

We are brought back to Merton's insistence that for both saint and artist, integrity and humility consist in an affirmation of the call of God within all the circumstances of an individual life. We are brought back to Guy Chase mowing a field of grass and discovering in it an intellectual, aesthetic, and devotional opportunity. Again, back to Merton: "It is not humility to insist on being someone that you are not."

ENDNOTES
1 Thomas Merton, *New Seeds of Contemplation* (New York: New Directions Books, 2007), p. 100.
2 Marcia Hafif, "Beginning Again," *Artforum*, Volume XVII No. 1 (Sept. 1978), p. 34.
3 Hafif, p. 34.
4 Hafif, p. 37.

UNTITLED
(BLUE GHOST)
1987
GOUACHE
ON PAPER
7" x 5"

18Still

4:24 &S M

ns, hear

4:25 hS M

4:26 iS M

life, the

4:29 iRev

4:30 kS M

hundredfold yield

e 26:12). Harvest

on of God's king-

One of the unforeseen fruits of having taught art history is that I have a head full of images. They often appear unbidden, by some mysterious process of association. While I have visited Guy Chase's studio, the memory of it is not what came to mind when I set out to write about the way he works. Instead, a ninth-century illuminated manuscript image of St. Matthew from the *Gospel Book of Archbishop Ebbo of Reims*, which is sometimes just called the *Ebbo Gospels*, appeared, recalled from years of reading and staring at the pictures in *Gardner's Art Through the Ages.*

Perhaps the association is because I think of religious books when I think of his work. It may also be because there is something about St. Matthew's looks and attitude that reminds me of Chase's approach to art. The Matthew of the *Ebbo Gospels* seems earnest as he concentrates on recording what is being told to him by an angel. But he also looks puzzled, quizzical, wind-blown, and slightly disheveled. It seems as though the whole task of mediating the Divine Word is a bit over his head and beyond his ability. Nonetheless he continues to labor faithfully and diligently, even as he questions and wonders.

One can see that quizzical attitude in Chase's art, such as a triptych that includes text from the Gospel of Matthew. *Hermes' Blues* is composed

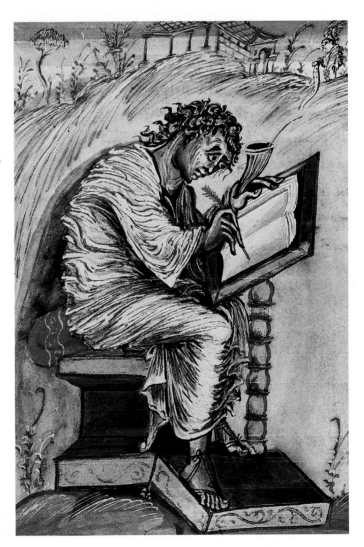

PAGE 30
HERMES' BLUES
(ULTRAMARINE-
MARK)
1995
WATER COLOR
AND ACRYLIC
ON PANEL
24" x 16"

PREVIOUS
ST. MATTHEW
EBBO GOSPELS
C. 1000
10 X 8

ABOVE
HERMES' BLUES
(INDIGO-
MATTHEW)
1995
WATER COLOR
AND ACRYLIC
ON PANEL
24" x 16"

OPPOSITE
UNTITLED
(9,000 DOTS)
1989
INK ON
CARDBOARD
11" x 5"

and characters.

The panels are different blues—Matthew's is indigo, Mark's is ultramarine, and Luke's is phthalo. Chase explains, "Each of the three panels contains elements of one of the synoptic gospels' presentation of the story from a particular version of the Bible, complete with footnotes, cross references, and commentary, all attempting to explain or help us interpret a passage which is about interpretation or understanding. The title, *Hermes' Blues,* refers to the root of hermeneutic, named for the messenger, Hermes." Thus, Christ's story about the difficulties of hearing and understanding his words is further complicated by an emphasis on how the different accounts of that story are "colored." This in turn both magnifies the need for but frustrates the possibility of an authoritative interpretation. Chase, somewhat like St. Matthew, records the Word, but unlike Matthew he does it with a modern, critical edge.

These panels show us how important *making* is to Chase's art. We intuit that the work requires a kind of *devotion*, because it makes us perceive the passage of time, preserved in painstakingly slow handiwork—the kind of work St. Matthew did as he wrote his Gospel. But Matthew didn't have a choice about recording technology, and Chase does. So why didn't he simply paint over a reproduction of the text? There is something dogged in his insistence on working so much by hand. The devotion to process is clear in a little 5" x 10" "altar painting" from 1989 that has 9,000 ink dots on cardboard. Below a carefully filled field of dots, a bit of spidery handwriting

of three 16" x 24" panels, each containing a snippet from one of the Synoptic Gospels' account of Christ's parable of the soils. He prepared the wooden panels with a ground of gold acrylic paint, and then projected the biblical text onto the panel, carefully transcribing it by tracing each letter, number, and graphic indicator with a pen. The panels were then painted again with the gold acrylic paint, which because it is somewhat transparent, allows the pen's ink to be visible under its film. Finally, a blue watercolor wash of inconsistent density was applied over the whole surface, with the exception of the fine goldish-dark lines that define the numbers

THE ART OF **GUY CHASE**

declares "finally, September 21, 1989."

It is understandable that we might see such work—which must be tedious—as something to be endured, like an office job where repetition and ennui are relieved by checking friends on Facebook or anticipating the weekend. This makes one wonder, "What's in it for him? Surely not money or fame." I don't think there *is* any automatic payoff for him, and certainly no substantive worldly gain. Chase has explained that "I work, expecting, waiting, listening, hoping for some connection, for some revelation, some divine intervention, some evidence of logos incarnate." Thus the primary reward is interior, and rooted in the Christian faith's devotional practices of meditation and prayer.

But his art doesn't look like the kind of imagery I associate with most contemporary devotional art—pictures of Jesus or Mary that seem to have been exhausted by generations of half-hearted imitation, one artist shadowing a predecessor without much insight, conviction, or an indication that they were personally engaged by their subject. In contrast, Chase's work is personal and unique, which is one of the cherished values of modernity. While his paintings may include bits of popular devotional literature, or reproductions of icons, their visual language is obviously modernist, and draws on the history and ideas of abstraction.

The split I see between Chase's modernist imagery and his creative practices rooted in Christian piety provoke questions. Why does he work this way, and how did he come to make these images? It is apparent that the questions

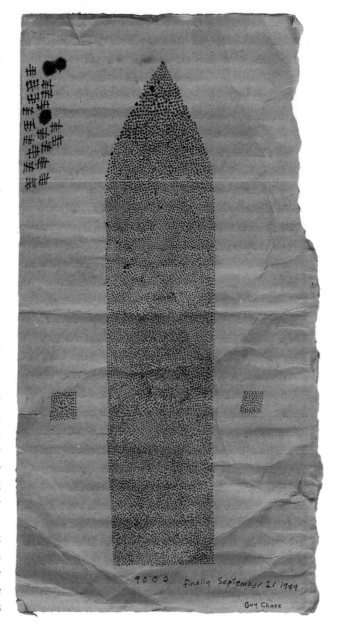

FILE FOR AN
ILLUMINATED
MANUSCRIPT

1989
WATERCOLOR
AND RESIN GLUE
ON PANEL
19″ x 36″

can't be answered solely by describing his studio habits, if by that one means "technique." I think it has always been true that the artist's choices are shaped by their convictions and intentions—their mental and spiritual frame. But this has been particularly true during the rise of modernity, where the artist is unconstrained by the obligation to produce conventional imagery; thus, some knowledge of their ideas and goals can make opaque work more accessible.

Chase's work can be illuminated by describing the two experiences that have most shaped him—his religious background and his education as an artist. The early religious life was shaped by conventional conservative

Protestantism. He attended Baptist and Bible churches growing up; he participated in the teen outreach Young Life and describes himself at that time as a "fundamentalist, evangelical, street witnesser." He worshipped at Willow Creek Community Church near Chicago in its early years, before that church became the archetype of the "big-box," seeker-friendly ministry it is known as today.

Chase went to Bethel College in St. Paul, Minnesota, intending to become a minister. But Bethel's art department, long known for its rigorous and dynamic program that is thoroughly engaged with modern and contemporary art, changed him. He was challenged by the faculty,

and became an artist because of the painter Dale Johnson's ideas and prayers. Johnson argued that "the artist is a minister, with a greater impact on society or a community over time, than any preacher." This change of study was not simply a career choice, but a call. At Bethel, Chase recognized that he had been "prepared from an early age to be a painter." The change also affected his conception of faith, as he began to see that thoughtful skepticism might be a means by which one could grow before God, by puzzling and meditating on questions raised by Christianity. He didn't really know what to paint, and so the act of painting itself began to take on aspects of faith.

Chase went on to get his Master of Fine Arts degree at the School of the Art Institute in Chicago, which is one of the most progressive—and prestigious—art schools in the country. He speaks affectionately of his teachers there, but it was a class in modern and contemporary aesthetics that made the most impact on him. By this time he was an abstract artist. His MFA thesis show of 1981 was made up of small watercolors based on loose grids. Each was created by placing brushstrokes next to each other, without the guidance of an underlying structure, so they appear homemade. Often the grids were variations on a single hue, and sometimes several grids share one sheet of paper. They are small, and need intimate engagement. These watercolors seem to approach what the Swiss artist Paul Klee might have made if he had studied with the Canadian artist Agnes Martin, or come under the spell of minimalism.

There is an aspect of Chase's color, the earnest whimsy of his lines, and the overall lyrical clumsiness of his paintings that is reminiscent of Klee. But the presence of the grid in his work is straight out of minimalism, even if its handmade execution questions or gently mocks minimalism's quest for purity, rationality, and exactitude. In the MFA show, one piece was titled *Prayer List*, and a couple were described as "altars," but no other religious signifiers were evident.

Later, Chase was asked at what distance his work should be viewed. He responded that it should be the distance required to view a book. It occurred to him then if he painted on book pages, it would draw people into the right relationship with the paintings. It is at this point that the beliefs and artifacts of Protestant popular culture became visible in Chase's work. The

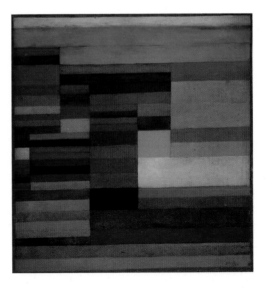

FIRE IN THE EVENING
PAUL KLEE
1929
OIL ON BOARD
14.6 x 14.2"

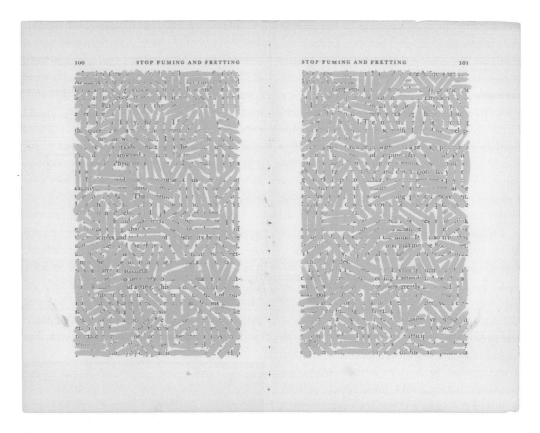

first book he chose to paint on was Norman Vincent Peale's *The Power of Positive Thinking*, which he began in 1982. He was familiar with Peale's book through a kind of pastoral succession. Bill Hybels, the pastor at Willow Creek, was inspired by Robert Schuller, the TV evangelist who founded the Crystal Cathedral in California. Schuller in turn was indebted to the work of Peale, the famous pastor of the Marble Collegiate Church in New York City.

Peale was known—and controversial—for fusing religion and psychology, even creating a clinic next to his church where people saw both religious counselors and psychiatrists. *The Power of Positive Thinking* came out in 1951. It was enormously successful, but also subjected to intense criticism. Some in the psychoanalytic community saw it as unprofessional, and without a solid psychological basis. Some in the Christian community were concerned by the emphasis on success and positivism, as though the power and presence of sin could be erased

UNTITLED (POPT-STOP FUMING)

1982
LATEX ON
BOOK PAGE
9" x 12"

32

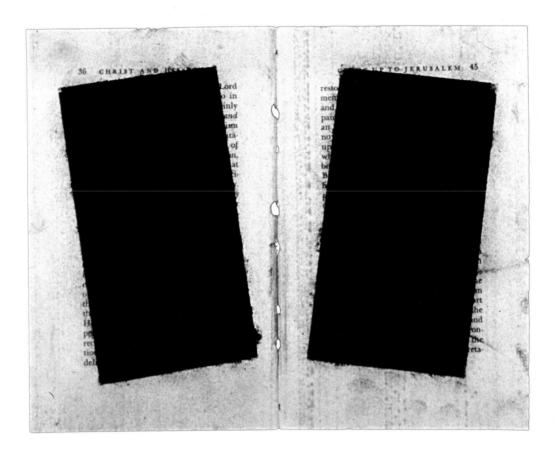

simply by adjusting one's thought life.

At Bethel, Chase had begun to question positive thinking's ideal of emotional and material prosperity, and he says he developed "a love-hate relationship with the book." But he liked the "poignant" chapter titles, and realized that they would generate a dialogue between the abstractions he painted on the pages, and the sentiments expressed by the titles. In effect, the paintings *comment* on the titles, by making

a visible image that resonates with and recasts the way we think about the titles.

There are many of these *Positive Thinking* paintings, all made on double-page spreads from an early hardcover edition of the book. The most predominant color is a kind of grey-blue, which gives a feeling of the institutional blandness and conformity derided by another popular book of the 1950s, *The Man in the Grey Flannel Suit*. However, making such cultural associations

UNTITLED (CAHC-DANCING BLACK)
1985
CHARCOAL ON
BOOK PAGE
7" x 9"

was not Chase's intent. He chose the grey to imitate the color of the book's block of type.

In this series, various permutations of grid design are common, but there are other patterns of painting too. The painting on pages 100 and 101, which says "Stop Fuming and Fretting," has covered the text with irregularly shaped units made of three to five parallel brush marks. The brush marks are all similar, though within a unit, some are longer than others. Each unit has a different direction in the overall painting, much like what Jasper Johns did in his "cross hatch" paintings of the 1970s. But the dry, cerebral quality of Johns is absent. There is something about Chase's strokes and overall pattern that is just slightly dippy, but not really silly. To my mind they have the kind of ineffectual energy appropriate to fuming and fretting, which has far less negative power than, say, hatred or anger. This painting, like others in the series, makes the small, passionless sins and natural ambitions for happiness and success found in one kind of popular Christian teaching visible and palpable.

Part of what indicates Chase's depth as an artist is that he can work through a visual idea and its conceptual frame without falling prey to easy repetition. Thus, some of his work on the pages of other popular devotional books have an entirely different emotional tenor, and are devoid of the wry humor that is part of *Positive Thinking's* charm.

A compelling example is an untitled work from 1986 that my wife and I own. It is from the book *Christ and His Cross*. The left page's title says "Christ and His Cross," and the right page says "Going Up to Jerusalem." You have to come close to the work to be able to make out the words "cross" or "going," because both are largely obscured by the corners of two dense, velvety, black charcoal rectangles. The rectangles are not parallel to each other nor to the body of the text they almost fully cover. They are tipped so that they fan away from each other a little, with the bottom inside corners closer, and the top inside corners farther apart. This arrangement implies a kind of movement, as if activated by *going*, or *carrying* a cross.

The two rectangles are physically on top of the text, but visually they appear to have been cut into it, creating a receding darkness that pulls at you. It is important that Chase didn't paint these rectangles, which would then sit on top of the paper like a film, something you might pick at with your fingernail. Instead he used charcoal's dusty, penetrating granularity, which is made from burning and compressing wood, a once living source. This profoundly simple image gives Christ's sacrifice and death a haunting physical presence, even as it declares an impending absence.

The Protestant culture that shaped Chase was mediated by words and fixated on them. It would be wrong to say there are no images in American Protestant culture, but they have existed in a narrow enclosure of proscribed uses. What he is doing doesn't really have antecedents within Protestantism. I am thinking here of the way he draws the Christian faith into conversation with modern art, and uses modern

art's imagery to comment on and adjust our perception of religious texts. But in doing this, Chase has also inverted the practices that were common to premodern Christian art, where the image was typically thought of as illustrating a religious text, and thus was expected to serve it. Chase's works don't really fit that old understanding of the text-image relationship, as the texts he uses serve the marks, shapes, and forms that sit on top of them.

Using book pages in the way that Chase did was also an uncommon artistic practice in 1982. It is easy to see it today as relatively commonplace, since many artists employ books or book parts as a material in their work. Pieces of printed pages first appeared in modern art with the Cubists as elements in collage, and pages and page parts are found in the collages of successive modern movements. But the idea of using a whole page as a support, and working on it in a way that drew its content into a dialogue with the artist's painting or drawing, had few antecedents. Chase was thinking and working independently—and with some freshness—in areas of *both* faith and art.

The modern artists that contributed to Chase's formal vocabulary were often from early twentieth-century movements associated with religious or spiritual aspirations, such as the Russian constructivist Kasimir Malevich.

UNTITLED (LEGAL
DIPTYCH WITH
APPARITION)
1989
GOUACHE
ON PAPER
11″ x 17″

The black rectangles in the untitled 1986 work I've described bear a striking relation to some of Malevich's paintings, except for the contaminating presence of the text underneath. Malevich's drive towards purity would never have tolerated such detritus from the real world. For him, and for many other pioneering abstractionists, the spiritual lay beyond the everyday. Part of what makes Chase's work inflected with a Protestant sensibility is his insistence on keeping the "real" attached to the sacred. This sensibility is also seen in how his elements, like the grid, never fully achieve what they connote. The faults and foibles of the hand making the grid are too evident, too *there* to ignore. They fall short of the mark, which is one way Protestants describe the fallen estate of humanity and our need for redemption.

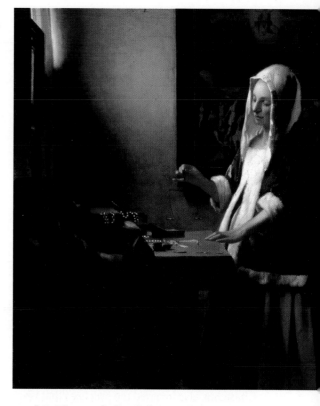

In later series, such as the *Legal Pad* paintings from 1989, or the *Ledger* group started after the turn of the millennium, the use of pre-existing book pages is abandoned. In these Chase has painted an entire page, mimicking the color and playing with the format found in the files or books of two professions: law and accounting. The majority are painted in gouache, an opaque watercolor that yields a deadpan drone when compared to the expressivity and vivacity we expect of transparent watercolors. In these paintings the final product appears less handmade, since he—like everyone who says they "can't even draw a straight line"—first drew the lines in with a ruler and colored pencil. He then carefully painted the color of the paper around the lines, which keeps what he calls "the human touch." Three of the ledger paintings were initially composed in a computer, printed, and then transferred to a gessoed panel with solvent. After this he traced each line in oil by hand, and then filled in around the lines with the muted green ledger-paper color.

Chase says he had been thinking about painting the ledger paper for years, because his wife, Lynn, is an accountant, and the paper was around. "But it just seemed too obsessive, too hard to paint all those little rectangles," he has said. A couple of things made him change his

WOMAN
HOLDING A
BALANCE
VERMEER
1486
OIL
26 x 20

mind. One was having a residency at the Tryon (now McColl) Center for Visual Art in Charlotte, North Carolina, which is the headquarters for some major financial institutions, like Bank of America. Another was the Enron scandal, with its exposure of the role financial accounting plays in culture. Given our country's last few years, Chase seems to have been prescient in making art that comments on finances.

If you divide cultural artifacts into categories like "secular" or "sacred," it is a safe bet that many Americans would put legal pads and ledger pages in the secular box. Yet by choosing these subjects, Chase was also recalling an old Christian tradition, which would have been evident to earlier, premodern Westerners. The idea of balancing accounts, of making sure that all of the items in the book add up, and that liabilities do not outweigh assets, is found in some Christian images pertaining to the Last Judgment. Thus in the late twelfth-century tympanum over the portals of the Cathedral of Bourges in France, we see an angel—smiling—weighing souls with a balance before a large,

UNTITLED
LEDGER #2
(BLANK PAGE
FROM THE
BOOK OF LIFE)
2001
GOUACHE
ON PAPER
22″ x 30″

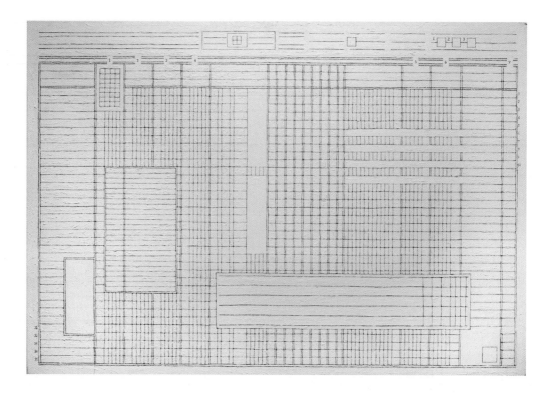

UNTITLED
LEDGER (LEDGER
FOR MULTIPLE
ADJUSTMENTS)
2001
OIL ON PANEL
15″ x 22″

enthroned Christ. There is a similar image in a painting from the 1660s by Johannes Vermeer titled *Women Holding a Balance*. The moral and religious import of this seemingly mundane domestic task is made clear by a large painting of the *Last Judgment,* which Vermeer placed on the wall behind the woman, who seems absorbed by the act of weighing.

At first glance the ledger paintings seem straightforward. It is easy to attend to their painstakingly exact quality even as we still see traces of the artist's hand. They also fuse the appearance of abstract minimalism with realist verisimilitude, looking a lot like "real" pages. However, titles like *Ledger for a Final Accounting* or *Blank Page from the Book of Life* direct us to the spiritual subtext below the appearance of an impersonal sheet used for computation. One work from 2003, *Ledger for a Final Accounting,* has a little cross formed by two intersecting rectangles slightly to the left of the composition's center. It is significant that the ledger pages are all clean, with no record of gains or losses.

The earlier legal-pad paintings recall the role of "the law" in Christian thought, which is

often described in Protestant theology in terms of the difference between the impossibility of fulfilling its demands and the free gift of God's grace. The forms of some paintings like *Untitled (Cross Page)* or *Untitled (Legal Plaid)* are laid out so that two pages intersect to form a cross, suggesting that law in some way constitutes the basis of the cross. Another, *Untitled (Legal X)*, is a single vertical page, but the double-lined red rule that normally forms the left column of legal pads has been transposed. Here, one double line runs diagonally from top left to bottom right, and another pair of lines from top right to bottom left, to form a large but delicate red X, as though whatever might be written there had already been cancelled ahead of time.

In describing Chase's work I have paid particular attention to the place and role of Christian thought and imagery. This is right and necessary, but it can also be misleading. While an abundance of the work refers to faith, it is not always his major subject or concern. A series like the *Projection Screens* from 1992, with their droll commentary on the way we use screens to project not only images, but our "view," is not primarily concerned with questions of faith. While the *Paint By Numbers Series* (1990-2004) has a *Loaves and Fishes* painting, and also *Deluge*, I believe Chase's intentions have more to do with art than faith. The content of the series strikes me as being about the presence of abstraction in a culturally lowbrow, popular form of representational painting. So it is necessary to emphasize how much of Chase's work is about *art* too.

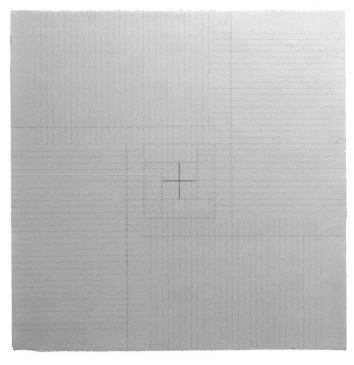

Here we come to an important distinction—between art with Christian *content*, and art with Christian *intent*. Christians, including some Christian artists, may see art as a means of communicating Christian subjects and beliefs, with the intent that the audience will understand and be moved by the content of the art. I don't believe this is how Chase works. One of the central tenets of modern art is that the artwork is a *personal* expression of the artist. The practice of "listening prayer" as Chase works is also *personal* practice found in some psalms and developed as the discipline *Lectio Divina* in early monasticism.

UNTITLED
(FOUR SQUARE
LEGAL PAPER)
1989
GOUACHE
ON PAPER
22.5″ x 22.5″

What is particular about the way he practices it is that his personal experience of making becomes the vehicle for contemplation and revelation. Thus he fuses two different understandings of what is meant by "personal" in the act of making. Chase's intent is to first understand his own world, and he is not generally oriented toward clearly communicating an idea with art. He recognizes, of course, that art *can* communicate, and paradoxically one of his motives in *Hermes Blues* was to embody the idea that clear, universal communication is not really possible.

Chase's most personal work, conceived in the slow, entropic experience of his marriage, is

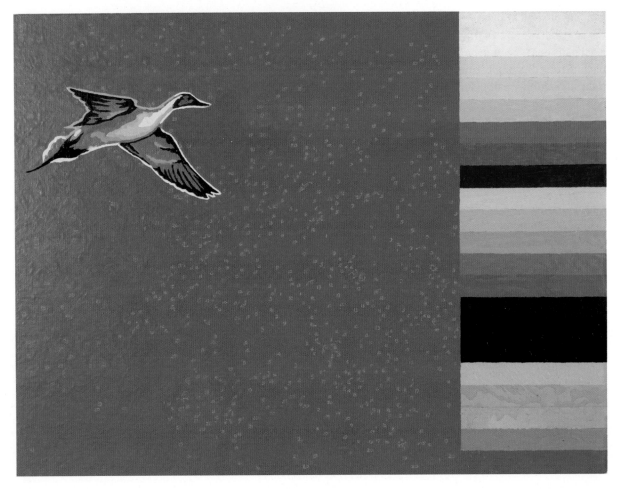

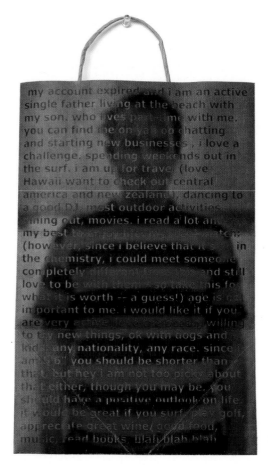

my account expired and i am an active
single father living at the beach with
my son. who lives part time with me.
you can find me on ya... oo chatting
and starting new businesses , i love a
challenge. spending weekends out in
the surf. i am up for trave (love
Hawaii want to check out central
america and new zealand) dancing to
a good DJ. most outdoor activities
...ning out, movies. i read a lot an...
my best ...ten:
(how...ever since i believe that ... in
the chemistry, i could meet someone
completely ...and still
lov to be with them — so take this for
what it is worth — a guess!) age is no...
important to me. i would like it if you
are very ... willing
to t... new things, ok with dogs and
kid... any nationality, any race. since i
am 5'6" you should be shorter than
tha... but hey i am not too picky about
tha either, though you may be. you
should have a positive outlook on life
it would be great if you surf, play golf,
apprec...te great wine/ good food,
music, read books, blah blah blah

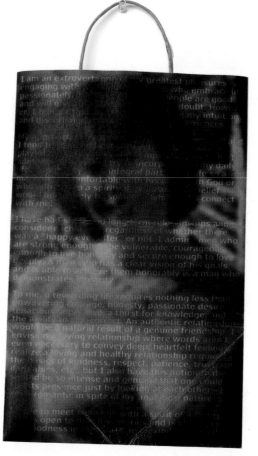

I am an extrovert ...ly greatest pl...sures i...
engaging wit...
passionately... who embrac... in
and will p... ...ople are good
...er, I ... doubt. How...
and doub... ...any intuit...
 ...er...nces

I feel...
playedar
adm... ...incor... ...y dail...
... integral par...
...omfortable w... ...h God or
wh... ...o a spir... ...elief
woul... ...ly ...y... connect
with me

I have ha... ...longer... ...ips and
consider... cl... regardless of whether the...
was a happ... ...ver after or not. I admi... men who
are strong enough... ...be vulnerable, courageo...
...nough to live hon... and secure enough to lo...
... ...a clear vision of his goals
and... ...able to ... them honorably is a man who
demonstrates ...

...me, a rew... ...ingures nothing less than
inwar... ...rge... ...ty, passionate desir...
... ...thirst for knowledge and...
the a... ...An authentic relation...
would be ... natural result of a genuine friendship I
envision ... ving relationship where words aren't
evenary to convey deep, heartfelt feeling...
... ...loving and healthy relationship requir...
theof ...indness, respect, patience, trust ...
... ...but I also have ...s notion ...at ...
...d be so intense and genu... that one c...
...s presence just by lo... ...f each oth...
...in spite of mynature...

...o meetwith ...sult of ad...
...open totu...
...odness m...

OPPOSITE
**COLOR BLIND
(21 COLOR, OIL,
PAINT-BY-
NUMBER)**
1990
OIL ON PANEL
12" x 16"

**MUST LOVE
LIFE, NO. 32**
AND **NO. 41**
2009
LASER PRINT
ON CRAFT
PAPER WITH
JUTE HANDLE
15" x 10"
EACH

about communication. *Must Love Life* of 2009 is a series of 70 color laser prints on wax-reinforced craft paper, which has the look and feel of grocery bags. After printing they were given folds like grocery bags, and jute handles were glued on, which makes the imitation of a bag convincing. Each bag bears the blurred "portrait" of an individual Chase found at match.com, a website where people search to meet others with whom they might become romantically involved.

Chase and his wife separated after he moved from Illinois to begin teaching at his alma mater, Bethel. As a result he began to use the site in an attempt to meet people. Every person on match.com has written a brief profile, trying to make themselves winsome, attractive, and alluring, and also describing what they desire in

25. Royal Doors. Left Leaf: ST JOHN CHRYSOSTOM. Right leaf:
ST BASIL THE GREAT. First half of the 15th century.
26. Half-length Figure of St John Chrysostom. De[...] the
left-hand leaf of No. 25

**UNTITLED
(ICON WITH
CHECKER BOARD)**

2009

GOUACHE AND
INK ON ICON
BOOK PAGE

11" x 8.5"

person's self-description, but to get a sense of how the person looks, you must step far enough back to reduce the blur. This is then too far away to read the text. So what do you choose: a discernable picture, or the ability to read someone's "self portrait"? You can only join the two in the space of your mind.

The whole ensemble is suffused with a melancholy irony. Chase has recorded the most hungry form of personal disclosures, and arranged them within that great, impersonal unifier, simplifier, and quantifier—the grid. There is something painful about the commercial aura surrounding the whole enterprise, as people try to sell themselves to unknown, anonymous viewers. He found that certain phrases like "must love life" or "loves to laugh" were used often. In explaining the piece he notes that he read profiles from all five ZIP codes where he has lived, and found a certain uniformity, as well as something missing, something *not* disclosed. He says,

"Although most desire a sense of humor in their potential mates, few exhibit any humor in their profiles. The proliferation of earnestness, positivity and optimism, in the end, bespeaks redundancy, bleakness and conformity. Since most people using these sites to find dates are divorced, one might conclude that many have failed in previous relationships. Even so, one reads little in these profiles about the years of counseling, or loneliness or depression—which

others. Chase printed the text of the person's profile over their portrait photographs, which became blurred during the process of enlargement. With these bags, the physical intimacy of viewer engagement that Chase looked for with the book pages continues, but it is also broken. One has to be close to the bag to read the

most certainly has been the case. (Well, at least in my case.) Maybe it's just me, but I find sadness in all this."

Must Love Life exhibits many of the characteristics seen across the body of Chase's work, such as the rich interplay between text and image. It is also marked by his self-deprecating humor, and his attentive search for discernment about what is right in front of us, before our very eyes. But it also—to me—embodies the profoundly troubling questions our culture of personal fulfillment grapples with. We long to be fulfilled, and to be validated as that uniquely wonderful person we know ourselves to be. And yet how do we do it? Why are we so unfulfilled? How can we commune with others if we are so unique? Why do we need someone else to find ourselves? Whose life must we love? Could it be that in order to love life, we really need to lose it? "Must lose life?" That doesn't sound very appealing.

There is another way Chase has changed his earlier artistic practice in *Must Love Life*. The "human touch" characteristic of his work has been displaced. It is not seen in the personal facture of his made object, but found instead in the small wobbles of slightly misshapen personal desire that we read on the bags. Thus the human presence is not physically experienced as much as mentally ascertained. This is consistent with the logic of the piece, and its origins in the smooth, physically elusive veneer of the Internet. While I miss Chase's hand in it, *Must Love Life* is marked by his spirit—it is I believe, recognizably his. He is in the work, not outside it as an aloof, authorial commentator. The piece came from using match.com, and in effect is part of his profile, and becomes his bag.

The way Chase engages his subjects is certainly conceptual in nature. Yet he doesn't strike me as a hardcore conceptual artist. The desiccating weight of the "idea," which I often feel in conceptually oriented work, is simply not present. The matter of his art has its own life, and though it mediates ideas, it is not reducible to them. While he is hardly traditional, Chase is clearly devoted to the craft of his art, and because of this he stands in an old tradition that locates art's uniqueness in its making.

In our culture there is a tendency to oppose the hand and the mind, but Chase's work repudiates such a simplistic approach by making thoughts that can only exist in matter. But his greater fusion, and the thing that gives his work depth, feeling, and singularity, is the way he has brought together a Christian spirit of reflection with the forms and ideas of modern art. The bridge between these two very distinct—some would say opposed—realms is found in his blending of their concepts about what is personal. Guy Chase, like the *Ebbo Gospels'* St. Matthew, is listening, but he is listening to art too.

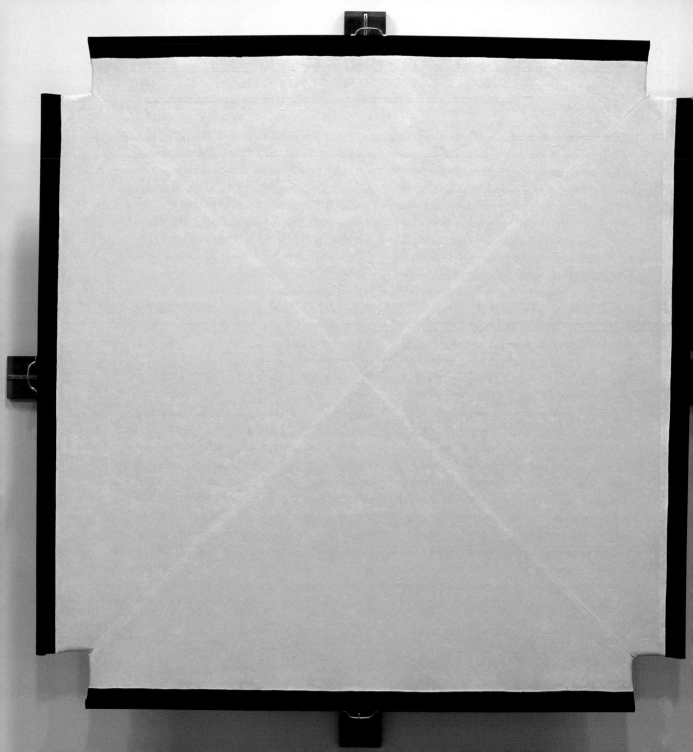

DISRUPTION AND ILLUMINATION

THE ROLE OF ART HISTORY IN THE ART OF GUY CHASE

The pleasure of understanding an artist's work unfolds by investigating it from many angles. This is especially true when the work is richly layered, as is the case with Guy Chase's art. One rewarding angle of inquiry is to consider the artist's relationship to other artists' work in art history. In Chase's art, there is a plentiful and playful relationship between his highly original inventions and artists of the past. Specifically, Chase's art is the result of a contemplative engagement with other artists who have asked questions about how the spiritual and the material, the sacred and the secular, the venerable and the mundane are related. His curiosity about how other artists have expressed these matters ranges from Russian icons to Gustave Courbet's combative Materialism, from the utopian mysticism of Kazimir Malevich's Suprematist abstractions to the Black Paintings of Ad Reinhardt and the formalist monochromatic abstractions of Agnes Martin and Robert Ryman. But not only to these. Surprisingly, Chase's inquiries into how certain images get at the tensions and relations between the spiritual and the material also engage him with mundane populist "imagery," including the columns of accountants' ledger books, the pages of legal pads, paint-by-number sets and religious self-help books.

In every case, what Chase learns from these sources is transformed through dialog with his own sensibilities. Fertile traces of these sources are visible in his many series of artworks. But as one studies these series, it becomes evident that his art is not merely some interesting art historical conversation about *what* we know of the spiritual and material via images. It is more profoundly about *how* we invent or discover imagery that enables us to navigate the terrain between the spiritual and material. In the end, Chase's work is, itself, an interrogation of the visual forms and art historical systems by which we express that terrain.

This essay, then, draws out Chase's visual dialog with other art and artists. This is not simply a matter of identifying his "art historical influences and sources." Rather, it is a matter of tracing his engagement with questions of meaning, which in turn is about his engagement with other artists who have posed visual solutions to those questions. But it is also a matter of tracing Chase's awareness of the nature of visual expression itself—of visual language and of art history's organization of visual language—and how all *that* is also part of his art.

A nice entry point into the issues is through two anecdotes that Chase himself tells. During his undergraduate days, a former professor, George Robinson, paused one day in art history class and asked his art students if they thought

OPPOSITE

MEDIATOR

1992

ACRYLIC ON

CANVAS WITH

WOOD AND

HARDWARE

SUPPORT

96" x 96"

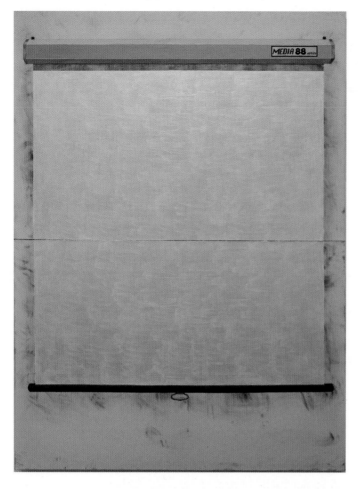

MEDIA88
1996
ACRYLIC
ON CANVAS
96" x 70"

In taking art history, he had been genuinely moved and provoked by past artists.

Later, as an emerging artist in need of paying the bills, Chase took a faculty position at a small liberal arts college. Because the department was small, he was required to teach art history. Thus he found himself wearing two hats and operating out of two, not entirely compatible, modes of thinking. He was the "working artist" in conversation with other artists past and present and he was the "art historian" presenting past and present art in packages of well-historicized orderings.

During this situation an odd epiphany occurred (though not all that odd for those who know Chase's nimble intelligence and humor). While lecturing one day he became conscious that the pull-down projection screen in the room was especially lousy. So lousy that it had a seam sewn horizontally across the middle of the screen, creating a raised line across every work of art he projected. Once noticed, that seam became to him a highly visible component within every image. He wondered if, when his students traveled to the Louvre, they would send him postcards expressing confusion because none of the masterpieces they studied in class actually had a horizontal ridge across their middle. Of course no one ever did. The seam had remained invisible to them as they looked "through" it at the projected images.

The point, he realized, was just how unconsciously and uncritically we edit our experience and rationalize our knowledge. How easily we look "through" the very ground that enables our

about their own art as being in dialog with artists of the past. Chase found himself answering, "yes." Not out of polite veneration for art history or youthful confidence, but because he was already discovering artists throughout history who were asking questions that felt vital in meaning even if their forms were not current.

seeing, as if it were not there, in order to focus on the "subject matter" or "content" projected onto that ground. Chase was intrigued by how we take for granted the physical ground of reality while enjoying the ideas it bears, as if the material substance and the intellectual or spiritual content were not inextricably coextensive.

It struck Chase that this visual situation was both a very funny and profound analog of human knowing. All those binary oppositions of body/mind, matter/spirit, realism/abstraction came to mind. It also struck him that the situation was a very mundane idiom for another opposition. The screen was a low quality object from the mundane world. In a sense, it stood for "low" culture. Yet here it was, tainting his conversation with "high" culture. For an American sensibility, this high/low relation may be as fundamental to meaning as are the more esoteric divisions of body/mind or matter/spirit. The situation with the screen asked, "exactly *what* are we looking at and *how* is what we see related to the fullness of reality?" The flawed projection screen in the dark shining with the lit shadows of art's great truths was a wonderfully trivial and deliciously contemporary version of a very long and venerable philosophical tradition.

In philosophical terms it was Plato's "Allegory of the Cave" and its legacy. In theological terms it was what religious icons celebrated and the iconoclasts worried over. In the artistic terms of his own generation in the 1980s, it was the debate between realism and abstraction. And hovering within that debate, was an internal argument over whether abstraction was a purely materialist formalism and or a transcendent spiritual expression.

What the sewn seam across the screen intruding upon Chase's consciousness did was make him aware of all these layers at once. It also confirmed his inclination for art that engaged all these layers at once.

The question of what the "projection screen" signified intrigued Chase to the point that it became the basis for his *Projection Screen Paintings*. In a beautiful insight, he realized that the projection screen itself stood as a most remarkable image/ground/form/subject mediating his concerns and the history of art. To borrow Charles Pierce's semiotic terms, it functioned simultaneously as index, symbol and icon. While it would be a mistake to read all of Chase's art through this one series, the *Projection Screens* so richly embody his interests, that they make an excellent beginning point for moving into all of his

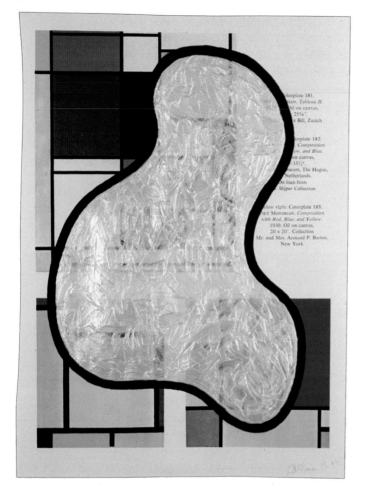

work. Three of them—*Mediator, Angels (with Courbet's Stonebreakers)* and *White on White*—nicely set the stage.

The very title, *Mediator,* addresses the pith of these ideas. In semiotic terms, what that projection screen signifies and mediates is a complex chain of referents. It simultaneously references a neutral white plane or object, a flat abstract monochromatic painting and a realistic representation of a projection screen. In this, it references the primary means by which physical objects, images, ideas, and realism or abstraction all coexist and interact. But it also references the art history class and art history's various paradigms for organizing those things.

Just as in art history, multiple concepts flow and conflict, so too all the layers of what *Mediator* signifies flow and conflict. Thus, one history of images borne on its surface belongs to the Renaissance and naturalism's tradition. In Leon Battista Alberti's definition, the Renaissance artist treats the painting's surface as the transparent plane of a window. "Through" it he creates a world analogous to nature using linear perspective, light/shadow and three-dimensional modeling. Just so, the art history class treats the projection screen as transparent window. It is "history" as window. We treat the screen itself as a transparency through which we look into the larger history and its world built out of naturalism's claims. Claims which began with the Renaissance conviction that through naturalism art invokes spiritual transcendence as embodied in creation, but which ended with Gustave Courbet's view that through realism nature is proven to be strictly material and, therefore denies the spiritual.

At the same time, the projection screen is an opposite kind of plane bearing other histories of quite different images. For it is also a

flat, abstract monochromatic surface. There is a nice visual pun here when a different history of images is projected onto the same screen—images that are, like the screen itself, flat, abstract and monochromatic. Now the screen becomes the ground or support for the projected illusions of flat abstract paintings that deny illusion and reject naturalism as truth. These belong to Clement Greenberg's brand of formalism that reduces paintings only to what is physically immanent: that is, the canvas support as flat plane, color shapes and paint. So here the "window" references formalism and radical Minimalism.

And yet, as Chase often talks about and has written about, flat abstract painting itself has a dual tradition.[1] In the hands of strict formalists, it expresses a radically materialist belief. But in the hands of its inventors, Kazimir Malevich, Vasily Kandinsky and Piet Mondrian, and later extended by Ad Reinhardt, Agnes Martin and others, it is a meditative form linked to the Christian icon, the Hindu Mandala and Zen meditation. In particular for Malevich, the Russian Orthodox icon mediates between the natural and the spiritual. In its "stand-off" between realism and abstraction, the icon is a taut membrane existing precisely between the transparent window of spirit and the opaque physical plane of matter. Here the Renaissance metaphor is reversed. As "window," the icon opens, not onto the natural realm of nature seen as illusion, but onto the spiritual realm of Divinity, which is abstract. And yet in its physicality

and simplified image, the icon also mirrors back what is immanent to the physical world. The icon is both window and mirror because it's meaning is to express Christ, who was both human and divine, both matter and spirit reconciled. With the icon, we look both "through" and "at" those images. So when the projection screen bears the particular history of images that are iconic, then the screen itself doubles as bearer of nature and of the spiritual. It mediates dueling traditions of images and their meanings.

Puzzle 133: Tricky

OPPOSITE
**UNTITLED
(SCREEN STUDY,
GHOST ON
MONDRIAN)**
1992
ACRYLIC ON
ART HISTORY
TEXT PAGE
12" x 9"

**UNTITLED
(SUDOKU
PUZZLE 133)**
2006
GOUACHE ON
INKJET PRINT
ON PAPER
44" x 30"

ANGELS
(WITH
COURBET'S
STONE
BREAKERS)
1992
ACRYLIC ON
CANVAS WITH
HARDWARE
65" x 72"

Given all this, it makes sense that Chase constructed the screen of *Mediator* itself to bear this duality. It is made of four triangular pieces of canvas sewn together so that the seams form a large "X" on its surface. But supporting this screen from behind is a large bracket against the wall shaped like a Greek cross. An "X" marks the physical spot on the map, "you are here," or marks where the surgeon makes the incision into the fleshy body. It references a neutral fact, a material reality. The Cross is a religious symbol marking the spot where Christ—the God/

Man paradox—died in this world under its material systems of power in order to give eternal life in the spiritual realm of God's Kingdom. The cross here is a spiritual support, a world behind the world. And exactly "between" the "X" and the cross in *Mediator*, hovers/stretches the iridescent membrane of the *Screen*, mediating between layers of reality, and bearing competing paradigms of materialism and theology as symbolic projections on its illuminated surface.

Mediator is rich because it is fraught with such tensions. Two other *Screen* paintings, *Angels* (*with Courbet's Stonebreakers*) and *White on White*, explore the opposite poles of these tensions. A comparison of the two will not only round out these ideas, it will also set up our understanding of other series of works. Each work presents us with a screen bearing a ghost image of a major artwork from art history: Courbet's, *Stonebreakers*, and Kasimir Malevich's, *Suprematist Composition: White on White*. These two works, both instrumental to the invention and meanings of Modernism stand at opposite ends of the tension between materialist and spiritual orientations. And in that they also represent opposite pictorial approaches to making a painting. Courbet as a staunch Materialist, championed Realism, while the mystical Malevich invented Suprematism in order to assert pure abstraction as a modernist icon for a Twentieth Century spirituality. Chase brings this debate into dialog via the *Projection Screens* by placing "ghost" projections of these seminal works on his *Screens*.

Courbet famously replied to the question

of why he never painted an angel by saying he would do so if he were shown one. Material nature was Courbet's Truth. Chase humorously, yet also seriously, references Courbet's materialism by using one of Courbet's most radical paintings, *The Stonebreakers*, and giving it the provocative title of *Angels* (*with Courbet's Stonebreakers*). *Angels* recalls Courbet's skepticism, while the *Stonebreakers* represents his Truth: reality is man laboring to survive and meaning is the survival of the fittest as embodied in class struggle. It is not the transcendent souls of these anonymous laborers working themselves to death breaking gravel that survives here. It is only their political ghosts lingering as a trace in the monochromatic abstract white field of the screen and students' memories. And by the time we arrive at the strict materialist views of Greenberg's Formalism, even their ghosts are denied.

Chase's manner of painting this image has real poignance. Describing the making

ARGH,
ARGH AND
DOUBLE ARGH
2005
INK ON
GRAPH PAPER
11″ x 8.5″

of this work, he insists upon something about the process. Once the canvas was given three or four layers of white iridescent paint, Chase projected the slide on it. He then traced each patch of form with pencil in a manner like a paint-by-numbers set. These he filled in separately with iridescent white paint, applying the paint in a different direction for each form.

Thus *texture* makes the ghost image, not *representational* marks or *expressive* brushwork as in a traditional manner of painting. Rather than *narrative* or *feeling*, it is more like utterly neutral bits and pieces of matter assembled into a semblance of something whole. This is not the solid, unified field of nature proposed by Courbet's realist confidence. It is more like what became of Courbet's Reality as Impressionism, that late stage of Realism, pushed materialism to its logical conclusions. Essentially, and somewhat ironically, Impressionism dematerialized Realism's solidity into the bits of colored light and pieces of form that are our perceptions. In this way, Materialism reduces reality into pieces of matter, detaching nature from narrative or metaphor in favor of a flat material abstraction.

We know, of course, that our perceptions of reality—of the thing-in-itself—are illusions. For what we really see with our eyes is not the facts of the physical object but the light reflected off its surfaces. Whatever the true nature of reality is, we cannot discover it directly with our vision. Instead we read and interpret their surfaces by way of how light waves are reflected. Courbet could not see angels, but he could see ghosts. These men may be present but they are nonetheless, painfully, invisible to society. Instead of angels or souls, Courbet asserted the harsh physical reality of the workingman's body, sweat and social insignificance; and thereby sought to establish his existence through realistic representation.

In Chase's, *Angels*, the ghost image of the two stonebreakers working their lives away

anonymously at the roadside is haunting. They turn their backs to us because viewers of art in 1849 were upper class and had no regard for such insignificant laborers, is haunting. Socially these men, as persons, hardly existed. We see them today only by way of Chase's radically neutralized realism; a sheer materialist ghost of the light bouncing off their textured surfaces in a slide.

With an edgy irony, the question of whether these men have souls or whether they simply disappear in history is raised by Chase's addition of this word, *Angel*. And through the iridescent white's dematerialization of these men in the projector's shimmering light, the tensions between hard physical materialism and the human yearning for spiritual hope, transcendent meaning and a more ultimate justice is exacerbated.

At the other end of the spectrum is *White on White*. This screen holds the ghost image of *Suprematist Composition: White on White*, one of Malevich's most transcendent icons for a Twentieth Century spirituality. Along with Kandinsky, Malevich was concerned with reinstituting the spiritual in art. He repudiated Courbet's materialism and realist style as a blind copying of surface, saying that the "Suprematists have … given up objective representation … in order to reach the summit of true unmasked art, … of pure feeling."[2] Theologically and aesthetically this had deep roots in Russian Orthodox icons, and Malevich's own brand of Christian-based mysticism, as well as in modern physics, utopian social ideals and

UNTITLED (ORANGE HATCHMARKS)
1997
FLORESCENT ORANGE MARKER ON PAPER TOWEL
108" x 90"

theosophy. Transcendent "pure feeling" was expressed through pure monochromatic painting, as an iconic white square rising tilted in suspension within a larger field of white, pulsing between differentiation and absorption into a larger Oneness.

Chase's own worldview is Christian and thus his sympathies lie more with the spiritual transcendence of those Orthodox icons.

But, while he hints here at *homage*, his keen awareness of the human capacity for self-deception and taking ourselves too seriously cause him to also quietly subvert any sentimental bliss that a sympathetic viewer might experience. He does this by having the screen become so long and narrow that the "projection" of Malevich's

work falls off its edges on both sides where it shines on the walls of the classroom/gallery.

This annoys (as every student and lecturer well knows) when trying to engage the sublimities of art's history within the mundane confines of classroom settings and lousy equipment. It disrupts the illusion of a spiritual reality, of art as spiritual, by pulling us back into the rational self-consciousness that this is just the discipline of art history. Or perhaps it is purely humorous, an ironic subversion disrupting our own "lift-off" and willingness to believe. In other words, whereas Chase allowed the need and yearning for angels and spiritual release to slip into argument with Courbet's materialism, he does the reverse in *Untitled (White on White)*. Here he allows the limitations of sheer physical or material reality—the too small screen and the walls of the classroom—to interrupt the spiritual epiphany of *White on White*, subverting the sublimity of pure abstract art and its aesthetic claims to reveal the spiritual. The image falling off the screen reminds us that this too is an illusion—just as abstract painting had previously shown that Realism's one-point perspective was an illusion.

And yet in doing so, a subtler hint of spiritual reality sneaks in. For now the shape of the "projection" interplays with the shape of the pull-down screen to form a cross. And this visual experience somewhat dissolves the physical planes of screen versus wall, suggesting that through the illumination of light, spiritual reality is both on the illusionary surface of our perceptions and surrounding us in physical reality. The total visual situation, then, implies that the spiritual is both *other than* and *congruent with* the material.

Regarding how Chase's own work in the form of the *Projection Screens* is mediating the issues of materialism versus the spiritual raised

OPPOSITE
SUPREMATIST
COMPOSITION:
WHITE ON WHITE
KAZIMIR
MALEVICH
1918
OIL ON CANVAS
31.25" x 31.25"

WHITE
ON WHITE
1996
ACRYLIC
ON CANVAS
AND WALL, WITH
HARDWARE
96" x 96"

by Courbet and Malevich, we might say that his *Screens* gather up the two sides of this debate; gather up this historical dialog and place them *within* Chase's own work. He makes both polarities of the dilemma immanent, inherent within his own imagery. He does this by building these *Screens,* which are themselves paradoxical. For they are literal physical objects that *realistically* represent actual physical objects existing in the real world of three-dimensions, even as they are also flat, monochromatic abstractions referencing light, the spiritual and the Beyond. Chase's own symbols/objects both mediate and suspend meaning. They leave us viewers, as good art should, on the cusp of our own perceptual dilemmas, which are in turn, analogous to our dilemmas of belief.

All of this comes together quite remarkably in the *Projection Screens.* But none of this was new in Chase's art when he made the *Screens* in the 1990s. His exploration of these tensions, and his use of past and contemporary

art and art history to explore them, runs through numerous other series. The dialog with other artists implied in the *Projector Screens* is, in fact, teased out in diverse and unexpected ways in his other series. In 1998 Chase wrote an essay titled, "Affirming Abstraction," in which he traced the tensions between the spiritual and the material from medieval architecture, the thought of Abbot Suger and Saint Bernard of Clairvaux, through the quilts of Amish communities, through Russian Orthodox icons and their influence on the invention of pure non-objective painting by Kandinsky and Malevich, up to the interpretation of Minimalism and monochromatic abstract painting of the 1970s and 80s when he came of age as an artist.

But this 1998 essay had a predecessor. In 1980 he had written his masters thesis on Ad Reinhardt. Art historians' collecting and publishing of Ad Reinhardt's writings had only begun around 1975, when

art historian Barbara Rose edited Reinhardt's writings for Viking Press.[3] In her acknowledgements for that publication she wrote that, "Reinhardt's ... prescient ideas enlightened an entire younger generation of artists and historians." In particular, it was knowledge of his ideas that helped to break the authoritarian grip of Greenberg's materialist formalism for that younger generation.

It is not clear how detailed Chase's knowledge of this scholarship was, but his sense of the importance of monochromatic abstract painting as an aesthetic "Möbius strip" in the argument between materialism and spirituality was exactly on target. Between 1975 and the 1990s, much would emerge about so-called Minimalist formalism and how Reinhardt's abstraction bore deeper spiritual implications that Greenberg had intentionally repressed. This became manifest as scholars brought out Reinhardt's relationship to Hinduism's Upanishads (Donald Kuspit), his dialog with Catholic monk and literary critic, Thomas Merton involving both Catholicism and Zen Buddhism (Naomi Vine) and his sense of the sacred in relation to the profane (Sam Hunter).[4] These revelations, of course, belonged to a much larger opening up of issues about meaning in abstraction related to spirituality that were emerging in detail during the 1980s. Those interests were extensively catalogued in the exhibition and book, *The Spiritual in Art: Abstract Painting, 1890-1985.*[5]

The perennial quarrel in human efforts to define reality either through material or spiritual

terms was situated in Reinhardt's thought with exactly the kind of wise and humorous irony that Chase sees as appropriate to human claims about ultimate things. Reinhardt's view that, "Art is too serious to be taken seriously,"[6] went hand in hand with his conviction that, "You can only

UNTITLED
(LEGAL TILT)
1989
GOUACHE
ON PAPER
11″ x 8.5″

73. THE VIRGIN. From a Deesis tier. 15th century
74. Detail of No. 73

**UNTITLED
(ICON WITH VIRGIN
AND BLUE GRID)**
2009
GOUACHE ON
ICON BOOK PAGE
11″ x 8.5″

make absolute statements negatively."[7] This fits Chase's own mixture of honest intellectual inquiry, spiritual depth and skeptical humor. And when he says, "all of my art somehow references abstract monochromatic painting," I take this to be a beautifully and creatively fraught statement.[8] Chase also acknowledges

being deeply influenced by Marica Hafif's 1978 essay in *Artforum* titled, "Beginning Again," where she spelled out some of the real complexities of this art quite early, even though in all those art history survey texts referenced in the *Projection Screens*, it was typically collapsed into the reductive and inadequate single rubric of "Minimalism."[9] In addition, he mentioned to me that he was also looking at the work of painter, Pat Steir, whose art was radically exploring the diversity of styles opening up to artists in the 1970s and 1980s, and how that pluralistic availability raised such interesting questions about meaning while blowing definitive or dogmatic positions on style or belief out of the water.

In investigating the role and meanings of Chase's use of art history, I began with the *Projection Screens* because they represent a moment in his career when he became especially self-conscious and reflective about these issues. He even said to me that, "oddly, the screens have very little of the obsessive quality that persists in my other work."[10] It seems to me that in this series he took a "step back" to investigate his interests more theoretically. In this, the *Screen* paintings offer a conceptual framework from which we can think about his other bodies of artwork.

If we look at the chronological arc of his entire career, we find that the *Screens* occur roughly mid-career. The works both before and after have, as Chase expressed it, a more "obsessive quality."

Therefore I would like to the discussion of his art into other series by leveraging off the

understanding provided by the *Screens*. My approach here is not so much to follow his work chronologically, for if one carefully lays out his historical influences next to the chronology of his various series, there is no neat parallel or progression. I prefer, then, to follow him more conceptually, working from series to series through connections of meanings and visual motifs.

Given that, it makes sense to turn to his series titled, *Russian Icon Books* of 1994-2009. These works have a deep richness regarding the role of art history. Indeed, they are probably more complex than the *Screen* paintings. But they operate within that more "obsessive" meditative mode of making that Chase says, "persists in my other work." In these works, he creates a spiritual meditation by way of interposing multiple "visual modes" into what I might call a kind of visual midrash.

One such mode is the tradition of the Russian Orthodox icon; another (which almost seems invisible in the same way that the projection screen would be invisible were it not for that sewn seam) is the pages of the art history book where he studied those icons. For the Russian icons that Chase uses in these works are not simply the icons themselves appropriated onto the artist's canvas. Rather, the "grounds" of these works are the literal pages cut from an art history book about Russian Orthodox icons. To remind us of this, Chase leaves visible the titles and illustration numbers in the upper left or right corners. Those words thus become part of the image, reminding us not only of the

hagiography in spiritual traditions, but also of the modern rational discipline of art history which catalogs these holy prayers as aesthetic objects and describes them in pseudo-scientific—not meditative—terms. Hence the spiritual and the physical, the transcendent and the material cleave together as per the contemplative process of icon writing, but also as per the

UNTITLED (ICON WITH JOHN THE BAPTIST AND GAME OF LIFE)
1996
GOUACHE ON ICON BOOK PAGE
11" x 8.5"

grids horizontally across the lower body of St Gregory the Divine, while floating a solid black cross drawn from the Suprematist paintings of Malevich across Gregory's shoulder and face, but also across the pure white of the page's margins. This abstract black cross "outside" the icon echoes with the smaller black cross held "inside" the icon in Gregory's hand. In icons, the flat ground indicates spiritual space, their monochromatic color, their precious material (usually gold) and their denial of naturalistic space all signify a spiritual reality "in front" of which stands the human saint with a physical body. This mediates the relation of Divinity and the material. By placing the modernist flat iconic shapes of Suprematism "in front" of all of this, the figure of Gregory now exists "between" spiritual zones, as one era's spirituality calls and responds to another era's spirituality. A sort of iconic midrash is set into motion between the ancient spirituality of Orthodox icons and the modernist spirituality of Malevich's Suprematism. And in this juxtaposing, Chase acts like those monks and Church Fathers who would add marginal commentaries and glosses to their predecessor's texts in medieval manuscripts.

Enriching this, Chase then adds various kinds of other marginalia. We see two tiny green "accidents" and a blue watercolor spattering. There is a feather-like plume of red, resonating with the red lettering of the icon. In the upper right corner we see small a small grid in watercolor. In, *Untitled (icon with virgin and blue grid)*, we see a larger grid in white with blue

UNTITLED (ICON WITH ANGEL)

2009

GOUACHE ON ICON BOOK PAGE

11" x 8.5"

rational process of scholarly historical writing and analysis. In a way parallel to the *Projector Screens*, the *Russian Icon Book* pieces are thereby suspended within two systems of knowing.

As he navigates and mediates these systems, Chase layers in three other visual modes. In *Untitled (icon with black cross)*, for example, he lays one of his own watercolor

THE ART OF **GUY CHASE**

lines blocking out part of The Virgin. These grids appear repeatedly in the *Russian Icon Book* paintings. Indeed, grids play a crucial—almost ubiquitous—role throughout his life's work. In various iterations, they constitute a significant form for him, both in their inherent qualities, but also in what they reference in other art. They even connect with mundane sources outside of art—graph paper, legal pads, accountants' ledger books—that Chase incorporates into other series.

Given the significance of the grid in his work, it is worth inquiring into the larger historical meaning of the grid. For the grid itself has a complex history that bears directly on the spiritual-material duality under discussion. Since the Renaissance, artists used a grid of strings as visual coordinates to help them translate three-dimensional space into a convincing illusion of natural space on the two-dimensional plane of the page. Then in contrast, the modern grid emerged as an intentional repudiation of this when Picasso dismantled this Renaissance language of illusion. He did so by way of the Cubist grid, based on

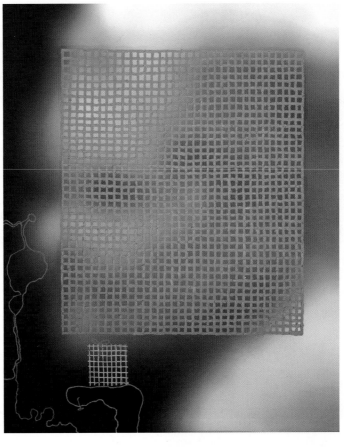

modern physics, constructivist understandings of reality, and materialist thought. For reasons too complex for the brevity of this essay, the Cubist grid morphed into the grid underlying Greenberg's materialist formalism. As art historian Rosalind Krauss argued in her essay title, "Grids," "the bottom line of the grid is a naked and determined materialism."[11]

Yet as Krauss also noted, other artists saw it

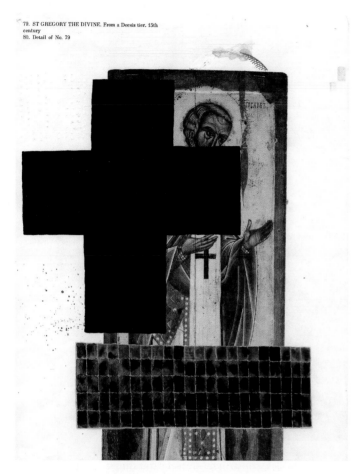

and the grid to dismantle Renaissance systems, but not in order to eschew metaphysics and establish a materialism. Rather, to pass through the illusions of representational styles and positivist material thought in order to arrive at spiritual essences within a modernist metaphysics.

Perhaps nowhere does the tension of this come out more clearly than in Ad Reinhardt's effort to create an utterly neutral grid of nine squares in his Black Paintings. We now know that there was a spiritual connection in those paintings, and that the utter neutrality was, itself, a means of mediating between the poles of the material and the immaterial, as well as of escaping human arrogance, dogmatism and polemics. Reinhardt's friendship with Thomas Merton, his relation to the mysticism of Hinduism's Upanishads, and the resonance of the *Black Paintings* in their neutrality with the Greek cross and the Eastern Mandala all pertain. The dilemma and paradox of this was also discussed by Krauss: "The grid's mythic power is that it makes us able to think we are dealing with materialism (or sometimes science, or logic) while at the same time it provides us with a release into belief (or illusion, or fiction)." Though Krauss favors materialism, her recognition that this form exists for human perception as both-at-once—as a membrane "between" (my words)—is testimony to the grid's role in this paradox.

Given all of this, Chase's way of making his grid's is enlightening. He says "his grids do not feel quite like the grids of these others,"

UNTITLED (ICON WITH BLACK CROSS)
2008
WATERCOLOR, ACRYLIC AND GOUACHE ON ICON BOOK PAGE
11" x 8.5"

differently: "But … that is not the way that artists have [always] discussed it. … Mondrian and Malevich are not discussing canvas or pigment … or any other form of matter. They are talking about Being or Mind or Spirit." Indeed, they used the grid precisely to get at their concern for reinstituting the spiritual through abstract art. They too used flat, geometric color abstraction

although he acknowledges that, "all of my paintings somehow reference monochromatic abstraction." The difference lies in his process of making. That is, his grid did not emerge as an idea or as a fundamental structural device for reconstituting painting. Rather, it emerged *as a process*. And for his entire body of artworks, *process* is crucial as his means for exploring and discovering, but equally as his means for meditating and contemplation. In his words, he began his grid forms by "just beginning to make without knowing exactly where it would go. By just making marks, by 'scribbling'." From such "scribbles" he began to structure the marks, which in turn lead to organizing them in a grid-like area on the paper. But the essence of these "grids" remained the fact that each little square was a single handmade mark. And in fact, given the watercolor medium he often uses, each little square is a nuanced single painting, which is evident if one examines his grids closely.

He liked the effect of this because while it allowed each little "painting" to have a unique quality, it also minimized the romantic potency of each. Which has to do with the Minimalists' interest in moving away from the highly personal and emotional qualities of narration or the emotion of "the authentic gesture." Instead, it balances uniqueness and individuality with humility and otherness.

UNTITLED (COLLECTION WITH GOLD TRIANGLE)
1986
WATERCOLOR ON PAPER
30" x 22"

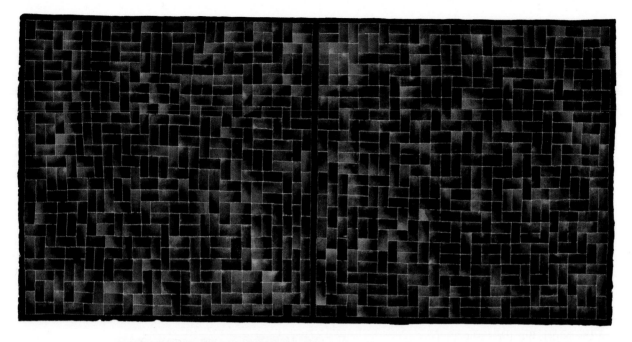

In other words, as per Krauss' observations above, Chase *is* talking about *canvas and paint* even as he is *also* talking about *material structure*, and about *spirit* and *belief.* He is talking about all of these as existing together in a unity that is simultaneously reasonable and mysterious.

In his early works he made multiple grids on large sheets of paper, with the idea that he would cut them apart into separate works. But he liked the total quality of these groups. They do, in fact have a certain kinship with the abstract geometric "narratives" of Suprematist compositions. Eventually Chase ended up organizing groups of grids on single sheets. Some he called, *Prayer Lists,* while others were organized

into forms reminiscent of altarpieces.

This digression into the meaning and iterations of the grid form enables us to enter more fully into his *Russian Icon Books* series. We have already noted the watercolor grid in *Untitled* (*icon with black cross*) and the white and blue grid in, *Untitled* (*icon with virgin and blue grid*). We can now see that one kind of abstract iconic dialect—the grid—is placed in relation to another kind of abstract iconic dialect—the Icon. Each era's spiritual understanding is embodied in each sort of abstraction. And when overlapped—when put into conversation together—they not only enrich and deepen our meditation; they also remind use that all of the imagery or "names" we use for

**UNTITLED
(GRID WITH
MIRROR)**
1981
WATERCOLOR
ON PAPER
20″ x 40″

Divinity are, at best, "names of names," "styles of styles," mere conventions to signify our inadequate understanding of the spiritual. They are in no way "real pictures" of the Divine. So, at the same time that it creates spiritual dialog, Chase's overlapping of different visual modes *also disrupts* the continuity or purity of each, just as that sewn seam across the canvas disrupts our illusions of unified knowledge as we sit talking in the dark.

In, "Affirming Abstraction," Chase pointed to the history of iconoclasm and how in its rejection (disruption) of images depicting Deity, it created another kind of imagery—an imagery of abstraction out of nervousness about realism's errors in claiming to portray the Divine. And so Chase's juxtaposition of different iconic abstract forms both mediates and humbles. It enriches the dialogue between different spiritual traditions, but it is also jarring in its juxtapositions. And in that, it reminds us that our expressions of the spiritual are at best "signs" of a mystery we cannot master, prove or portray.

To these three visual modes (the art history text page with words and photographic reproduction; the Russian icon itself; and the grid) Chase then adds layers of marginalia, building up a substantial dialog of spiritual investigation held in check by rational awareness of our language forms, and kept in humility by humor and irony.

We are made self-conscious of how our symbols and images are leveraged off of each other. Their aesthetic beauty signifies but in no way portrays Deity. And yet it moves us toward a sense of transcendence that references an Otherness, which is invisible and immaterial. As with the sewn seam across the screen, we become simultaneously self-conscious of our own constructed systems of thought *and* are transported into a sense of Otherness implied by the limitations of those very constructions.

Other series take up these matters in quite different ways. For example, the grids discussed above have a different application in his *Ledger Painting* and *Legal Pad* series. In these the grid now also references very mundane and secular sources in the legal and business worlds. Namely, the pages of accountants' ledgers and legal pads. Here, Chase discovers grids that are Ready-Mades. But as he transforms them, their ready-made secular function takes on metaphoric meanings that relate to the spiritual.

Despite their initial appearance as mass-produced objects of conformity, these are each original hand-made paintings. As such they feel like two things at once: highly realistic renderings of legal pads or accountant's books *and* abstract grid paintings. To accentuate that tension, Chase distorts or rearranges what we expect from such pages. Thus, the play between realism and abstraction remains operative.

But that visual play is not so much about clever retinal deceptions. It is about the play between mundane human practices such as keeping arithmetical financial accounts for legal purposes and the less rational calculus of ethical behaviors and ultimate spiritual accountings. As humans we exert considerable

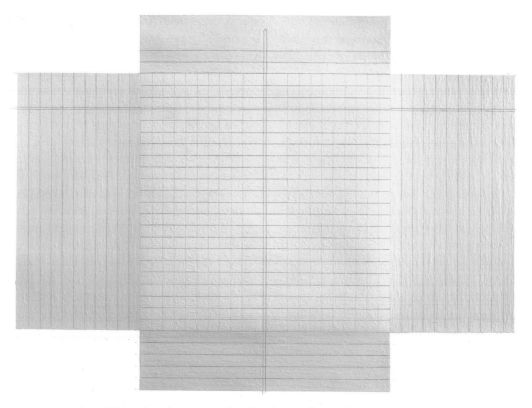

**UNTITLED
(CROSS PAGE)**
1989
GOUACHE
ON PAPER
15″ x 22″

energies to keep life ordered in rational col-
umns that add up. Yet our ways of rationalizing
do not always add up. Even our use of the word,
"rationalizing," bears opposite meanings—"to
make clear ordered sense of phenomenon" and
"to deceive ourselves by pretending we have le-
gitimate reasons for unethically manipulating
those orderings." Just so, our initial association
with legal pads or accountants' ledgers is that
these record the true state of affairs. However
the viewer instantly sees that Chase has altered
these pages to indicate that other motives and

logics always "has manipulate the books."

One of the meanings of "irony" is that there
exists an incongruity between the literal mean-
ing of something as stated and its actual mean-
ing, which may well be the opposite of the literal
meaning. A ledger book's accounts, for example,
are an arithmetical summation of what "one is
worth." The initial appearance of Chase's image
alludes to one's quantifiable worth within the
material, financial and legal worlds. But closer
inspection finds Chase altering the books, re-
aligning their columns and lines so that what

THE ART OF **GUY CHASE**

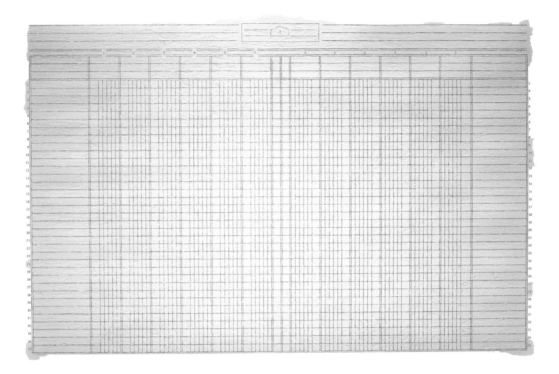

they add up to has spiritual implications. In his reordering, these pages begin to resemble the diptych and triptych formats of religious altarpieces. His subtitles reinforce the association: *Untitled* (*legal diptych with apparition*) or *Untitled* (*cross page*). Here a first level of irony rises up. For who can doubt that the primary religion of our culture is the financial bottom line, profit and the worship of money? And who can doubt that our rationalization of this through our merging of capitalist wealth and Christianity's spiritual wealth in various forms of "the Gospel of Wealth" is one of the most profitable/salvific rationalizations of history?

But the Bible speaks of more ultimate ledger sheets. It speaks of final judgments and whether one's name is written in the Book of Life. Hence, *Untitled* (*blank page from the book of life*) and *Untitled* (*ledger for final accounting*) are both funny and ominous. Central to the Christianity's idea of grace is that the arithmetical sum of our lives will never add up to save us, but rather will condemn us.

Thus Christian altarpieces, in their portrayal of last judgments, are about the accounting and assessment of one's "worth." The Bible ominously proclaims just such a final accounting as Last Judgment. Perhaps this is not an irony. For the

UNTITLED
(LEDGER FOR
A FINAL
ACCOUNTING)
2001
GOUACHE
ON PAPER
22" x 30"

ironies. And Christian altarpieces, though they portray judgment, are also about a spiritual accounting that involves, not the arithmetic of numbers but the calculus of love, grace and mercy. Indeed, that involves redemption from our rationalizations. This is the supreme irony.

Thus the artist, like God, manipulates columns and lines. Close inspection of how Chase realigns these reveals the slippage of multiple ironies and logics. Just so, the tensions between materialist realities and spiritual realities are also about tensions between justice and mercy. While Chase's irony tips towards humor, God's tips toward grace.

Somewhere between what the *Russian Icons Books* and the *Ledger Book Paintings* achieve, stands another body of Chase's works using books. That is, literally using actual books. There is a long and great tradition of visual artists interacting with books and spiritual texts.[12]

Chase's *Book Paintings* build on that tradition. One book he use was Norman Vincent Peale's, *The Power of Positive Thinking*. This book had a large impact on American religious life, and beyond into the flood of positive thinking, self-help and gospel of wealth books. Perhaps assuming our generic knowledge of this book, Chase selected chapter titles or page headings summarize Peale's gospel: "Try Prayer Power" and "How to Create Your Own Happiness" for example, are juxtaposed as a diptych. He then uses paint to redact the text in the form of twin grids, leaving only snippets of Peale's advice like teasers at the bottom of the pages. In the

"state of human affairs" is, in fact, exactly "what it appears to be": a thoroughly rationalized system of well-ordered corruptions and deceits. Even our altruisms are suspect.

But Christianity is, above all, a faith full of

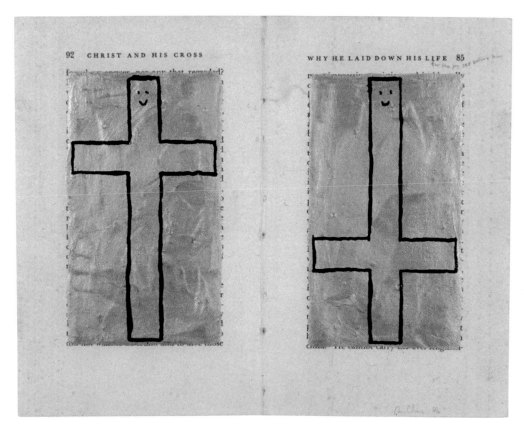

spaces between the painted rectangles, bits of black font still appear, creating a puzzle maze of connections between each segment. Here the interaction of spiritual text and the spirituality of monochromatic abstract painting play off each other. The linear words unfold narratively as one reads, taking in their logic while the pure abstract color fields hover, implying a state of being. The sense of some *logos* running beneath the worlds' forms is hinted at, although the real connections remain enigmatic. Whether this is a devout meditation or a humorous negation also remains enigmatic.

Other *Book Paintings* slip from straight forward to brooding to funny. A work such as *Untitled Book Painting (tcifac 100 & 101)* achieves a highly satisfying combination. Here the spiritual diptych form is repeated three times. First as two pages of the book's text ("The Cross in Faith and Conduct"; "The Message from the Cross"); second as an iconic diptych of gold ground nested within the text; and third,

HAPPINESS
AND JOY
(CAHC 92 & 83)
1986
ACRYLIC AND
INK ON
BOOK PAGE
7" x 9"

"idea session," the purpose of which is to tap all the cre-
ative ideas lurking in the minds of any of the four. For

which the Lord hath made; we will rejoice and be glad

**UNTITLED BOOK
PAINTING (POPT
62 & 75)**

1982

LATEX ON

BOOK PAGE

9″ x 12″

as a deep black iconic diptych nested within the gold. The white margins of the book pages in relation to the blocks of text echo with the gold margins in relation to the blocks of black. One is reminded here of apophatic theology, where the most internal mysteries are beyond words. As the Fourth Century apophatic theologian, Gregory of Nyssa put it, "If the thought is inadequate to the Reality, and the language is inadequate to the thought, then think how inadequate the language is to the Reality."[13]

Thus in Chase's piece, we move from outward articulation of language to inward abstract gold forms of spiritual space to mysterious black forms of the silence and mystery. But when we arrive at the center, we encounter an irreverent yet weirdly moving, cobalt blue Smiley Face split by the gutter of the book. Suddenly the iconic face of Christ suffering for our redemption is switched with the iconic smiley face of clichéd happiness. Should we laugh or be insulted? As Ad Reinhardt

noted, "Art is too serious to be taken seriously." Perhaps Chase takes the same attitude, not only toward art, but also toward religious faith and spiritual guidebooks. The irreverent shock of the kitschy Smiley Face takes us aback. Faith and mockery, truth and skepticism, precious materials and cheap kitsch, the earnestly sincere and the smart irony; all these hover here— as they do anytime humans engage big claims.

But all the mystics and theologians warn us that our representations of God's innermost mystery are, at best, symbolic. And the Bible tells us that, at heart, God is love, joy, and happiness. And Reinhardt reminds us that, "you can only make absolute statements negatively." So what traditional or earnest symbol would, in today's jaded world, be adequate? Why not choose the utmost of clichés to remind us of love and joy, while also warning not to trust in our own eloquence or righteousness? Or perhaps this is ultimate cynicism?

"And after that day, Jesus spoke to them only in parables, saying, Let him who has eyes to see, see."

ENDNOTES

1 "Affirming Abstraction," CIVA Newsletter (Fall, 1998).

2 *Theories of Modern Art, A Source Book by Artists and Critics,* ed. Herschel B.Chipp (Berkeley: University of California Press, 1968): 344

3 *Art As Art: The Selected Writings of Ad Reinhardt,* ed. Barbara Rose, The Documents of 20th Century Art (New York: The Viking Press, 1975).

4 Donald Kuspit, graduate seminar on modern artists and their writings, Rutgers University, 1981; Naomi Vine, "Mandala and Cross," *Art in America* vol. 79 (November 1991):124-33; Sam Hunter, "Ad Reinhardt: Sacred and Profane," *Record of the Art Museum, Princeton University* vol. 50, no. 2 (1991), pp.26-38.

5 *The Spiritual in Art: Abstract Painting, 1890-1985* (New York: Abbeville Press and the Los Angeles County Museum of Art, 1986).

6 (1962; cited by Hunter, p.27)

7 Kay Larson, "Shaping the Unbounded," *Buddha Mind in Contemporary Art* (Berkeley: University of California Press, 1997): 67ff.

8 Conversation with the artist, August 8, 2010. All direct quotations of the artist come from this conversation unless otherwise noted.

9 Marcia Hafif, "Beginning Again," *Artforum* 1978 September. Available at http://www.marciahafif.com/beginning.html.

10 E-mail to the author, 7/27/2010.

11 Krauss, "Grids," *The Originality of the Avant-Garde and Other Modernist Myths* (Cambridge, MA: MIT Press, 1985):9-22].

12 See Barbara Tuchman, "Hidden Meanings in Abstract Art," The Spiritual in Art, opus cited: 71-61.

13 Jaroslav Pelikan, *Christianity and Classical Culture: the Metamorphosis of Natural Theology in the Christian Encounter with Hellenism* (New Haven: Yale University Press, 1993): 92ff.

My initial encounter with the art of Guy Chase was framed with skepticism. I had come to the biennial conference of Christians in the Visual Arts at Messiah College desiring a complex, theologically nuanced dialogue about art and faith and longing to find sophisticated, challenging works of contemporary art. I braced myself for another disappointment. Upon arriving, I immediately went to see the exhibition mounted for the conference; the truth about the artist is always in the artwork. Looking around the exhibition, I was drawn to a quirky little painting by an artist unknown to me. It was a small 16- by 12-inch stripe painting on canvas board by Guy Chase.

Canvas board stood out as a noticeably odd choice for this painting, since such an inexpensive support denotes amateurism, while the Minimalist concept of a stripe painting typically relies on a rarefied sense of connoisseurship and sophistication for impact. I was also struck by the odd color sense. What was the rationale behind this seemingly incongruous progression of colors?

As I approached, I could see that the stripes were modulated, not with artfully layered brush strokes like Robert Ryman might use, but in a clumsy, lumpy way. Upon closer inspection I could see that each stripe was an awkward collection of small shapes with a miniscule line delineating the shapes like a collection of distorted and misshapen cells separated by pale blue cell walls as viewed under a microscope. But even more oddly, each cell was numbered with a tiny, pale blue number created by the under-painting. As I stepped back again, these shapes converged into some type of pattern. Then it dawned on me: this was a paint-by-number set!

The wall label informed me that it was a "21-color, oil, paint-by-number." I counted—there were 21 stripes, each painted with only one of the pre-mixed colors from the set. I later learned that the progression of colors from left to right was determined by the numerical order of the colors specified in the instructions. The first stripe was color #1, the second stripe color #2, and so on. The under-painting creating the pale blue lines was the result of the artist meticulously painting around the lines and numbers pre-printed on the canvas board.

Taken as a whole you could discern the image of ducks on a pond imprinted on the paint-by-number canvas. The work took a formulaic, amateur pastime and transformed it into a technically stunning, conceptually provocative and deeply personal work of art. This jewel of a painting was not the monumental, bombastic work we might expect from an ambitious twentieth-century American artist trying to

OPPOSITE
UNTITLED STRIPES AND HORSES (21 COLOR, OIL, PAINT-BY-NUMBER)
detail
1990
OIL ON PANEL
12″ x 16″

make a mark, but rather an intimate, humble piece, teeming with complexity on such a diminutive scale that it could easily be passed over if you weren't paying attention.

I began asking everyone I met if they knew Guy Chase. Soon I was able to introduce myself and express my admiration for his work. Over time, seeing many more of his paintings and engaging in conversations with the artist, I came to discover that the character of Chase's paintings—precise, brilliant and quietly subversive—exactly reflect the person. I walked in that afternoon guarded and suspicious, but it dawned on me that if an artist like this was featured, then I would have to check my skepticism at the gallery door.

A great painting, like a great ballet, is spectacular and seems beyond the bounds of normal human ability while simultaneously appearing to be effortless and spontaneous. But when the *pas de deux* ends with the dancers frozen in their climactic poses with the audience cheering, you can see though your opera glasses that the smiling dancers are gasping for air and sweating profusely. The magical sense of ease comes from extreme discipline, skill and exertion; the appearance of spontaneity results from a rigorous regimen of training and choreography.

Likewise, painting employs a system of techniques and compositional tools. When utilized with conceptual inventiveness and executed with exceptional skill, the result can move us deeply. This capacity for humble materials such as pigment, oil and linen to be transformed into objects capable of transforming *us* is why shrines to art (museums) have been built to preserve these slight, flimsy objects for the ages.

Chase's art is born of his own cultivated way of seeing the world, documenting his unique perspective with humble materials, and imparting to the viewer a creative way of seeing. He has developed his artistic vision, resting on a rigorous conceptual foundation and executed with masterly skill, resulting in works of nuance, depth and complexity. But for me, the most compelling testament to Chase's work is that his paintings have transformed me.

To appreciate Chase's artistic project, one must understand the visual and conceptual system that informs his observations of the world and his methods for making art. His approach to making pictures grows out of a historic framework that undergirds the history of easel painting in the Western tradition. These histories and

narratives of Western art are much studied and, to say the least, much contested. My aim is not to make any claims for a "right" reading of art history, or even of Chase's art (I will leave that to art historians and theorists), but rather to trace an intellectual strand I see woven through the warp and weft of art's historic fabric that—to my eye—reveals a pattern evident in Chase's work.[1]

Since the Renaissance, the systematization of linear perspective has provided artists with a powerful tool for representing three-dimensional "reality" on a two-dimensional surface. With the development of rigorous methods for applying the rules of perspective in the fifteenth century, painting was transformed. Perspective, both linear and atmospheric, along with detailed and systematic anatomical studies by artists, reflected the spirit of discovery and objectivity that permeated the Renaissance as it germinated and grew in the artistic fields. The artist now had powerful and seemingly objective tools by which to transcribe the visual information before him and document it on paper and canvas.

Utilizing these newly refined tools, the artist was able to create convincing representations of visual reality on two-dimensional surfaces. A deepening sense of "realism" grew. The pictures functioned by inviting the viewer to mentally pass through the picture plane, entering into the pictorial space and inhabiting the world created by the artist. As in great theater, a great painting draws the viewer in, causing her to completely lose track of where she is and allowing her mind to inhabit the reality created by the artist. We can be transported, but this transportation

requires our willingness to "suspend disbelief." We must willingly engage the fiction of the play, the novel or the painting in order for the illusion to work its magic.

The development of perspective was driven in part by the desire to accurately and objectively depict the world around us. This pictorial framework, which relies on an illusionistic depth of field allowing a viewer to "enter" the painting, is a force that continues to shape the way we view art in the West. But with mastery of the tools of perspective and with the later advent of photography, artists began to push on the conceptual underpinnings of this pictorial strategy—for example, the implicit notion of a singular point of view required by the rules of perspective. Linear perspective organizes the picture around a single viewer.[2] An artist like Pablo Picasso pushed at this idea overtly in his

UNTITLED
COLOR SPOTS
(21 COLOR,
OIL, PAINT-BY-
NUMBER)
1990
OIL ON PANEL
12″ x 16″

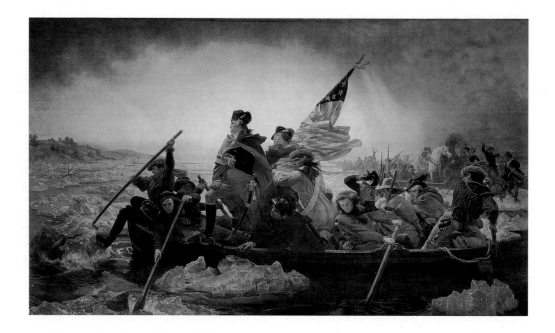

Cubist paintings. Would not depicting a still life from six points of view simultaneously within a single painting create an image that is six times more realistic?

Additionally, if the artist draws attention to the fact that this painting is actually a two-dimensional surface and not a mystical window into another world, wouldn't this be more "real," more honest than creating an illusion of depth? These developments were part of the ongoing quest for *the real,* long pursued by philosophers, theologians and artists, but which has always been contentious and conflictual. It is this tumultuous quest for *realism* that underwrites Chase's humble yet ingenious enterprise.

The dialogues and arguments that inform

Chase's work can be seen by tracing a conceptual thread through time. Focusing on American painting, we could start with *Washington Crossing the Delaware* by Emanuel Leutze, circa 1851. This work is a fanciful composition in which the artist observes the pictorial rules of perspective to create the illusion of depth. Within that pictorial framework he uses compositional tools to forward symbolic and metaphorical content.

General Washington is depicted standing in a boat with other soldiers rowing across the Delaware River in what turned out to be a decisive moment in the Revolutionary War. Washington is looking sternly into the distance (toward the left side of the canvas), trying to see

WASHINGTON CROSSING THE DELAWARE

EMANUEL LEUTZE
1851
OIL ON CANVAS
149" x 255"

what lies ahead for him and his country. The waves are strewn treacherously with shards of ice, and the clouds roiling in the sky portend the risks that lie ahead.

Rising above everything, in the center of the composition, is the American flag, wrapped around the flagpole by the turbulent wind. The flag's position suggests that Washington is sailing into a headwind, but its twisting and wrapping indicates the winds are shifting and uncertain. So hangs the fortunes of the Revolution. The flag is literally and figuratively the center of Leutze's composition; it serves as its symbolic and interpretive core.

In a different way this is true of Jasper Johns' *Flag*, completed in 1955. Johns' *Flag* is not a painting *of* a flag—the painting *is* a flag. He made a flag out of paint as a seamstress might sew a flag from pieces of fabric. Johns is not using the flag symbolically, as Leutze did, to encode metaphorical meaning into the composition. Rather, he is trading on the fact that the flag by its nature is a symbol.

When Luetze painted an image of the particular flag flying in Washington's boat, he created a representation of a symbol. This

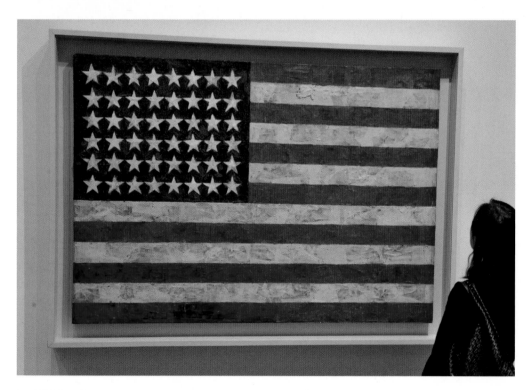

FLAG
JASPER JOHNS
1954
ENCAUSTIC, OIL, AND COLLAGE ON FABRIC MOUNTED ON PLYWOOD (THREE PANELS)
42.25" x 60.625"

Photo ©Mark Bryan Makela / In Pictures / Corbis

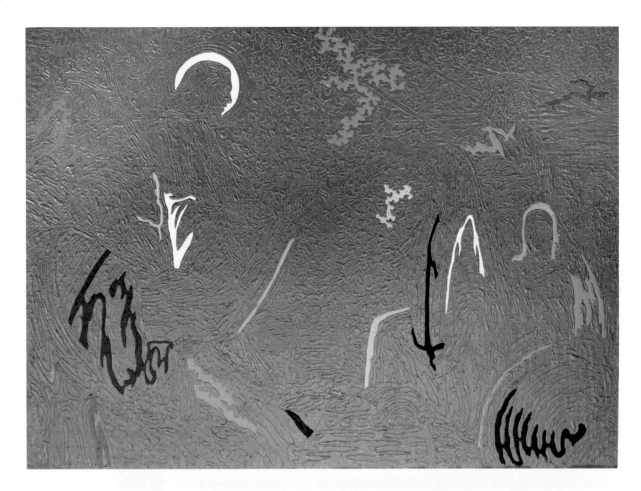

**LOAVES
AND FISHES
(21 COLOR, OIL,
PAINT-BY-
NUMBER)**
1990
OIL ON PANEL
10" x 14"

representation is removed from the thing it-self—it is a "re-presentation" of an actual object. Johns might argue that this form of pictorial "re-alism" is a fiction. It presents a facsimile of the real flag flying over the waves of the Delaware. Johns' flag, on the other hand, *is* a flag. The painting does not contain symbolism; it is itself a symbol. The pictorial distance between the

viewer and the subject matter is removed. *Flag* does not have some symbolic scheme that one must interpret to get at the real meaning—it is the real thing. Johns was continuing the quest for *the real*.

Brice Marden is an example of an artist who went one step further. If Johns made a painting that was itself a symbol, but wouldn't it be even

THE ART OF **GUY CHASE**

more real if the artist were to make a painting that was just a painting and nothing more? Marden's *Untitled* (1971-72) is a painting of three equal, horizontal stripes—two gray ones divided by a taupe one. These stripes are just stripes. These are not the stripes of a flag, and their horizontal disposition does not indicate the direction of the wind. They make no intentional reference to anything outside the painting itself. Marden seeks to represent a deeper reality by shrinking the scope of painting's field of vision. He utilizes a pictorial strategy to deliver a painting—nothing more, nothing less.

This may seem like the end of the line in this literalist quest, yet some artists still noted a problem. Paintings do not materialize out of thin air fully formed. Marden first had to have an idea for a painting and then work out the composition. What would the exact dimensions of the canvas and each stripe be? What specific mix of paints would be used to achieve the desired color, and so on? Wasn't he trying to accurately represent the picture he had in his mind's eye and reify it? Wouldn't his mental picture be more *real* than the mimetic painting, which was in fact merely an attempt to represent this idea?

Sol LeWitt developed a pictorial strategy to address this problem. He created ideas for paintings and drawings, but not the paintings and drawings themselves. He would develop an idea and create exact written instructions as to how the work should be made. A museum or collector acquiring a LeWitt does not in fact purchase a physical object—there is no painting. A buyer purchases the idea, the instructions

for what the painting is. The museum or collector is welcome to execute the instructions and install the described painting on the wall. They are also welcome to paint over it and move it to a different wall whenever they choose.

Seeking a deeper, ideal truth, LeWitt created pure ideas for paintings that were not tainted by the shadowy process of translating a work into the physical world. A viewer looking at a Sol LeWitt wall mural understands that she is not viewing the real work of art, but merely a particular representation of the work installed by a hired crew, never touched by the artist's hand. It is not necessary for the viewer to suspend disbelief in order to enter into and engage the work of art. The real work of art is the artist's ethereal concept, suspended in the non-corporeal world of ideas.

The historical precept of *the suspension of disbelief* became itself the object of suspicion. The quest for *the real* led some artists to engage their disbelief—that is, to express their skepticism. An analytical quest for "the truth" of a painting grew out of the skepticism inherent in the scientific method: something is not true until proven. The scientific method proved to be an extremely powerful tool that required all variables be controlled and all assumptions systematically tested. Nothing could be left to chance, and one's belief had to be completely removed from the equation in order to obtain objective and therefore useful results.

Artists saw the power of this method and began to pursue artistic knowledge in a similar fashion. This approach to art required a new way for the viewer to engage it. No longer must

we suspend our disbelief; we must engage it. This led to the entrenchment of disbelief.

The fundamental questions that undergird the work of Guy Chase grow out of this conceptual quest for *the real* as played out in the history of twentieth-century Modernist art. The scientific method and its axiomatic assumptions—inherent skepticism, control of variables—shaped much of the century's artistic activity. Art retreated from the realm of everyday experience into a sanitized realm removed from the contagions of the world. Chase challenges these assumptions and asks how we can make critically engaged art that is openly connected to everyday experience, intellectually rigorous yet not beholden to skepticism. In other words, can art rescind disbelief?

We can trace the development of Chase's ideas by tracking the development of his paint-by-number paintings. Looking at Chase's *Untitled* (*Stripes and Ducks),* we see he has invented a new set of pictorial rules to supersede the received rules. In a witty double meaning, he subverts both the literal rules set out in the instructions received in the paint-by-number box, as well as the larger set of conceptual "rules" of making a contemporary work of art. The scene of ducks on a pond imprinted on the paint-by-number blank adheres to a popularized view of what makes "good" art. It depicts a pleasant, pastoral scene using attractive colors and the rules of perspective to create a "realistic" depiction.

This populist version of art would be sneered at by the avant-garde, yet all these attributes are respected and even celebrated in Chase's re-invention—the scene is accurately depicted and the colors unchanged. Two stringent systems have been married, and the conceptual concerns of each have been amplified and transformed by the other. He thus draws a comparison between the rules of paint-by-numbers and those of minimalist painting. Is a craft-store paint-by-number set any more or less formulaic

than a "high art" stripe painting?

He also turns the tables on the low-brow view of an amateur pastime. The quality of paint we are all familiar with in paint-by-number paintings is still apparent—the odd, enamel-like satin gloss and the somewhat lumpy paint surface left by the brush strokes—but these familiar attributes are elevated by his technical skill. Chase has created a pictorial system that transforms a recreational diversion into a compelling, conceptually rigorous, critically engaged work of contemporary art. Not bad for a $10 paint set.

Chase develops this further in *Loaves and Fishes* and, nine years later, *Actual Things in Their Own Color*. In *Loves and Fishes* (1990), the artist uses a similar paint-by-number set but employs a variation in his pictorial system. He finds the largest shape indicated for each of the 21 colors and paints, each one its designated color. For the remainder of the shapes he made a mixture of all 21 colors, resulting in a muddy gray, and

painted the remaining shapes individually, leaving the printed lines meticulously unpainted. The image imprinted at the factory on the paint-by-number canvas, can, with some scrutiny, be detected. This biblical scene depicts Jesus miraculously feeding a crowd of thousands gathered to hear him preach. Jesus and his disciples feed the crowd with only a few dried fish and some loaves of bread offered by someone in the throng. In the biblical story the fish and loaves are miraculously multiplied, providing such an abundance of food that after everyone eats their fill, there are baskets left over.

Overall this painting is monochromatic. "Monochromes" and stripe paintings are both iconic forms of Minimalist painting. But this monochrome is violated by 21 individual shapes and colors wriggling around on the canvas. These eccentric interventions into the clinical gray of the painting are like bacteria being cultivated on the gray agar of a Modernist Petri dish.

What hearty strain of popular visual and

COLOR #13
A DISTANT
FOREST IN
MORNING HAZE
11″ x 13″

COLOR #14
FALL LEAVES ON
FOREGROUND
SAPLING
15″ x 13″

COLOR #15
ORANGE AUTUMN
LEAVES
12″ x 17″

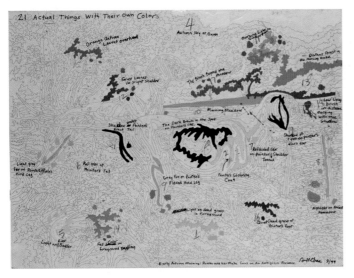

Key for **ACTUAL THINGS WITH THEIR OWN COLOR (21 COLOR, OIL, PAINT-BY-NUMBER)**
1999
OIL AND PENCIL ON PAPER BOARD
12" x 16"

religious culture can thrive in this new environment? Can Jesus and the crowds stand up to the homogenizing effects of modern life and modern art? Can art survive the infection of popular culture, or does some genetically altered mutation result? (Here we would need to look to Andy Warhol for some insight). All these questions are part of Chase's strategy to embrace the conceptual rigor of contemporary art while breaking the hermetic seal, allowing the outside world of popular culture and religion to seep in.

Chase returns to this basic format to pursue these ideas further with *Actual Things in Their Own Color* (1999). Here the artist locates the largest shape for each designated color within the paint set. He paints each of the 21 shapes its proper color according to the instructions, but this is not the finished work of art; it serves as the interpretive "key." Based on this key, Chase

manufactured sculptural reproductions of each of the 21 largest shapes at a 100-to-1 scale. He then painted each large shape the appropriate color. Seeing these eccentric, abstract shapes removed from their original context and mounted on the gallery wall, they seem to be abstract paintings born out of the personal invention of the artist's imagination.

The works could easily be read as intuitive, poetic and personal abstractions along the lines of artist Elizabeth Murray's work. In other words they appear somewhat intriguing, but ultimately, veiled, personal abstractions. They bear poetically evocative titles like "A Distant Forest in Morning Haze" and "Dark Brown in the Spot on Pointer's Side." It is only when the viewer realizes that these shapes and colors are exact-scale enlargements of individual sections of the paint-by-number set that the shapes take on their full meaning. The evocative titles are, in fact, accurate descriptions of what role each particular shape plays in the original composition. The titles inform us that the shapes are highly realistic reproductions of "actual things." No romantic subjectivity here!

In the earlier paint-by-number pieces, Chase was engaging the hard-edged objectivity of minimalism, but with these newer works he utilizes the same visual system to engage an opposing strategy focused on personal expression and subjectivity. The earlier work exposed the clinical detachment of minimalism to a dose of the outside world in order to build up a healthy pictorial system capable of surviving outside the artistic laboratory in the real world.

THE ART OF **GUY CHASE**

"Real Things" infuses highly personal abstraction with a dose of rigorous and critical thinking in order to inoculate against the delirium of romantic individualism.

Utilizing tropes of contemporary art—from monochromes to personal abstraction—Chase tweaks our perception. His rigorous and penetrating way of looking through the microscope at art and the world around him reveals things not visible to the naked eye. In a matter-of-fact way, infused with a playful sense of humor, he alerts us to the fact that we are surrounded by a deeper, spiritual, underlying reality that is available to us if we are willing to question the "rules of the game" and have the audacity to write in some of our own.

The conceptual systems we have traced through Chase's paint-by-number projects are also in evidence throughout his various painting series. His *Legal Pad* paintings, for example, hearken back to Jasper Johns' flag paintings. Whereas Johns created a painting that was a symbol, Chase makes a painting that is, well, a piece of paper. He takes the framework of Johns'

UNTITLED
(LEGAL TABLET)
1989
GOUACHE
ON PAPER
15" x 22"

How "real," then, is a symbol that exists in a realm completely immune from everyday reality? Isn't making a painting on a piece of paper *of* a piece of paper more connected to everyday life? Isn't that more real?

The *Legal Pad* paintings don't rely on the inherent power of an existing symbol; they serve as an icon of everyday life. Legal pads are mundane items we read neither as symbol nor as object. We read what has been written *on* them while they remain virtually invisible. They are the ubiquitous backgrounds on which we write our inspirations as well as our grocery lists. Yet in Chase's hands they subtly shift from the inconspicuous into perceptible symbols of the everyday.

In *Untitled (Legal Plaid)*, Chase paints two sheets of watercolor paper to take on the likeness of a pair of yellow legal-pad pages. But the familiar pattern of red margin lines and blue horizontal lines is oddly askew. The artist has adapted the well-known industrial pattern— blue and red lines on a yellow ground—into a playful, decorative plaid.

Like an Orthodox icon painter, Chase *writes* an icon to the everyday on the blank watercolor page. Or like Vermeer's paintings of domestic scenes that celebrate the sanctity of daily life, Chase elevates the most common of everyday materials into a playful symbol suggesting the possibility that the patterns of our daily lives—even the most mundane—are a hidden trove full of deeper meaning. Chase reveals that a perpetually blank page displayed for our contemplation is not a meditation on

UNTITLED (ICON WITH PURPLE TRIANGLE)

2009

ACRYLIC, WATER-
COLOR AND
GOUACHE ON
ICON BOOK PAGE

11" x 8.5"

argument about *the real*, namely that it is more "real" to make a painting that is not mimetic of something else but is exactly what it is (i.e., a flag), and turns it on its head. The symbol of the flag exists in the Platonic realm of the ideal.

If a truckload of American flags were destroyed in a fire then a lot of merchandise would been lost, but the American flag still exists—it would have not been damaged at all.

nothingness—it is a clean slate ready to receive inspiration or revelation. We come to see that a blank slate may be imprinted with a pattern of hopeful anticipation.

Prayer Square (1997) consists of an eight-foot by nine-foot grid of white paper placemats commonly found at local diners. The artist has used a coffee cup dipped in coffee to print hundreds upon hundreds of coffee rings on the grid of placemats, leaving only a six-inch border around the outer perimeter un-stained. The large composite "print" (or is it a painting, or a drawing?) that results is another monochrome of sorts.

The repetitive, laborious and hypnotic

UNTITLED (COFFEE SQUARE)
1997
COFFEE ON PLACEMATS
96″ x 108″

methodology is reminiscent of the minimalist paintings of Agnes Martin, but unlike Martin's work, Chase evokes a host of external references: an early morning cup of coffee for a time of prayer and reflection, a men's Bible study meeting at the local diner, the collective observations of a waitress.... Once again Chase synthesized Modernist rigor with the happenstance of everyday life to create an icon of the commonplace.

More recently, Chase's *Sudoku Paintings* (2006) express a further development of his visual system. During a period of stress in the artist's life, he began working Sudoku puzzles at night before going to sleep. These mesmerizing puzzles can absorb the player into their mathematical world. His conscious mind drawn into the realm of numbers and patterns, Chase would jot in the margins thoughts, prayers and pleas that would surface. Later, in the studio, the artist would remove the page from the book and paint each square of the grid black, carefully painting around the printed lines and handwritten

THE ART OF **GUY CHASE**

numbers. Chase mixed his black paint in an attempt to exactly match the black ink of the printed grid so that the lines and numbers would "disappear," adjusting the color as he progressed.

The resulting black grid/number painting once again hearkens back to Jasper Johns, this time to his *Number* paintings. Chase's numbers are not Platonic symbols, as are Johns', but the contingent and unsteady work of human inquiry. The pattern of the Sudoku is not predictably linear as in Johns' painting (0 to 9 repeated over and over), but is circular and complex. The attempt to make this multifaceted and seemingly random pattern of numbers disappear and fade into the painted field is analogous to the act of doing the puzzle in order to forget about the complications of life, allowing the problems of the day to fade into the background.

When the complexity of the numerical pattern blends into the monochromatic field, what becomes most visible are the seemingly random thoughts that surface in the margins of the artists mind—regrets, prayers, longings. The act of painting does not cause the artist to suspend disbelief or express skepticism, but rather to struggle with the real concerns and complexities of the world. Ultimately, it engages his belief. These paintings serve as personal meditations and acts of prayer—a collection of psalms that follow the poetic rules of Modern painting, yet, like all great poetry, transcend and even transform those rules.

Chase's work is conceptually rigorous and visually complex yet remains intimate and unassuming. His unique way of seeing the world has been made manifest through his conceptual strategy of representing a concrete realism. Chase's matter-of-fact paintings do not require the viewer to "suspend disbelief" in order to enter their world. On the contrary, they reach out and enter *our* domain, inviting us to be more deeply engaged with the poetic and spiritual reality that lies just below the veneer of the every-day.

Like the generous onlooker in the parable of the *Loaves and Fishes* who offers Jesus his small portion of food, Chase humbly submits his artistic offering. This act of faithfulness is blessed and multiplied, providing sustenance to those hungering for rich aesthetic nourishment. It was this deep hunger I felt so acutely when first encountering Chase's work many years ago in Pennsylvania. Seeing his sharp, witty, challenging work that day sent a chill up my skeptical spine and caused me to move beyond my doubt. I have come to see that Chase's work does more than merely rescind disbelief; it imbues hope.

ENDNOTES

1 Ideas about representation have been developed at great length by many theorists from E.H. Gombrich (The Story of Art) to Walter Benjamin ("Art in the Age of Mechanical Reproduction"), along with countless others. My cursory mention of a few issues relating to representation is merely meant to broach the subject as an issue that contemporary artists must grapple with.

2 For an influential treatment of this topic, see "Art in the Age of Mechanical Reproduction," or the book that popularized many of Benjamin's ideas, *Ways of Seeing* by John Berger.

James Romaine: Some of your art, such as those works painted on Russian icons, employ overtly "religious" imagery. Other works, such as those in your series *Must Love Life,* appropriating profile photos and texts from a dating website, seem to be "secular"; at least they don't seem overtly "religious." How do you regard these categories of "religious" and "secular" in your own art?

Guy Chase: There is very little by way of religious imagery in my paintings on icon-book pages. The book pages do contain pictures of icons. And while the actual icons are religious, the book pages I used came from art history textbooks. These textbooks don't have an especially religious purpose.

I don't think that my paintings on icon-book pages are any more religious than any of my other paintings. In fact, most of the imagery that I have painted over the icons is drawn from my other paintings and may not be recognized as religious by those people who are not paying attention.

On the other hand, when I made the *Must Love Life* series, I considered the audience, which was a religious one. *Must Love Life* was a set of prints commissioned by Christians in the Visual Arts (CIVA) to be gifts to guest speakers at CIVA's 2009 national conference.

JR: That connection is interesting, even humorous, because conferences are places where people often hook up, although that sort of thing seems to happen less at CIVA conferences. Still, CIVA conferences are opportunities for like-minded people to meet. So, the common theme between CIVA and Match.com is one of people seeking out each other based on a shared religious affiliation. Was religious affiliation one theme of *Must Love Life?*

GC: I thought about religious affiliation being one of the sought-after characteristics of people using a dating website. Many individuals on the site are quite explicit in their search for people of like faith. Several of the profiles I quote make reference to religious faith. One thing that struck me in making this series was that so many people on the site project something close to Christian values. Most, if not all, of the women listed "honesty" as a quality they were looking for in a match, and that helps make this work Christian to me.

JR: Is a work of art "Christian" because it is honest?

GC: I don't use "Christian" here to refer to a narrowly historical religion. Rather, if something is true, good or beautiful, it connects to God and is Christian. There is an art, or actually a

OPPOSITE

UNTITLED

(GRAPHITE

SQUARE)

2009

PENCIL ON

GRAPH PAPER

55″ x 60″

kind of behavior, that is associated with the religion called Christianity, that may not be interpreted as true, good or beautiful. An art that presents the accoutrements or vocabulary of Christianity may be called Christian, but if it feels dishonest or lacking in integrity, then its relation to truth, goodness, and beauty will be questioned. To me it is not Christian.

**MUST
LOVE LIFE,
NO. 12**
2009
LASER PRINT
ON CRAFT
PAPER WITH
JUTE HANDLE
15" x 10"

JR: Although it is not as much of an issue now, as it was when you began as an artist, there are still some who regard beauty with suspicion. Why is beauty important to you?

GC: I hold beauty, and therefore art, in the highest regard. Art requires beauty. Beauty means it touches on the most important things. If we talk about God in relation to this—beauty originates in God. Wherever God is, there is beauty. Wherever I perceive something as beautiful, it is because God is there.

JR: As it relates specifically to your own art, what is honesty?

GC: Honesty is not an especially formal or conceptual quality, and there are no rules for identifying it. When I made the *Must Love Life* series, I knew it might be controversial, but the relevant themes were part of my real experience. And by relevant themes, I mean there was something very real and honest about this pursuit of relationship. It was my pursuit. It was born out of difficulty, loneliness, and depression. I was admitting to these even as I discovered other ironies and even absurdities. I had been thinking about this work for several years. Even though the audience might not see it, I still felt that the honesty of it would be powerful. It is an art that comes from real, honest, and especially difficult experience. That is the art that must be done; that makes it religious. To not do it would be dishonest, and therefore not Christian.

THE ART OF **GUY CHASE**

JR: Is your objective, as an artist of faith, to be honest about the human condition?

GC: I try to be honest to my own condition. I think that, applied across the board, artists (and, well, everyone else) should be honest about their own condition, and, in that sense, my work is about the human condition. I don't really think of addressing "the human condition" as my goal. I don't start with a message I want to convey.

One thing that seems consistent is that my work grows out of some actual lived experience; it is inspired by something from my everyday life.

JR: Could you clarify what you mean by "honest" and "dishonest" art?

GC: First of all, it is a feeling one has. It is not an exact science. In my own experience of art, I might not consider something "art" if it felt dishonest. In an institutional sense, it might fulfill necessary characteristics associated with "art," but even then, I might dismiss it or disregard it if it seems dishonest to me.

JR: What do you mean by "institutional" art?

GC: I'm thinking of George Dickie's institutional theory of art. I read his institutional theory in an aesthetics anthology in graduate school at the School of the Art Institute of Chicago. One aspect of his theory contends that a painting in an art museum is "art" because

the institution gives it validity. Still, I might go to the museum and completely overlook it, in which case, it won't be art for me. Some people give more credibility to the institution's choices than to their own, and vice versa. But ultimately they should think for themselves and experience art for themselves and then maybe judge our words based on their own experience.

MUST LOVE LIFE, NO. 33
2009
LASER PRINT ON CRAFT PAPER WITH JUTE HANDLE
15" x 10"

JR: If you are skeptical of the institutional theory of art, are you also skeptical of an institutional theory of God?

GC: Many people have an institutional definition of God that is given to them from within the institution rather than one from their own experience, which may be based on the Holy Spirit's inspiration. Within the institution it is taboo to rely more on one's own experience than on the institution (tradition, fellowship, Scripture). I value the institution (art, or church), but I value my own experience as well. Sometimes more. Usually more. I err on the side of individualism.

JR: Do you recognize a tension or exchange between the institution and the individual as having its own value or necessity?

GC: This back and forth between institutional and personal experience of art (or God, for that matter) seems crucial. For me, the institutional should always depend on the personal experience. When it isn't, when we blindly follow the dictates of an institution, we lose our authenticity or our integrity. I would rather disregard all the institutional art and just have a personal experience with beauty. That would be religious.

The beginning premise is, "All truth is God's truth. And therefore, all beauty is God's beauty." Any experience of beauty originates with God. Any experience of God must be beautiful.

Things become art not by choosing so

much as by mystery, by gift, by surprise. That also makes all art religious for me. All art is religious for me. I like to make conclusive statements like this, with my eyebrows raised. It is as much a question as it is a statement of fact.

JR: What is your critique of the categories of "secular" and "religious" art?

GC: The categories of "secular" and "religious" seem inadequate to both art and life. I am a religious person. My life's work is religious work. My preferences, my values, etc., are formed by my faith. And even now, or continually, the task is to see more and more of life as "religious," or God-imbued. So, nothing is apart from God.

JR: If nothing is set apart from God, than distinction between "religious" and "secular" in art or "sacred" and "mundane" in life are erased, or perhaps it is better said that they are redeemed in Christ. Is that what motivates your work such as the legal pad series or devotional texts onto which you painted flowers and smiley faces?

GC: The legal pad series had a different origin. Those paintings memorialize a moment that became sacred to me: the moment when inspiration occurs, when you get an idea. Sitting in front of the blank legal pad, in a sense, praying for ideas, the pastel yellow, blue, and pink context becomes the setting for divine inspiration. With the smiley faces and daisies, I wasn't initially interested in redeeming the

OPPOSITE
UNTITLED
(SMILEY DAISY
DEVOTIONAL)
1986
ACRYLIC,
SILICA SAND,
OIL AND DAILY
DEVOTIONAL
BOOK ON
CANVAS
48″ x 36″

mundane or finding its sacredness. Rather I was suggesting a mock challenge:

> Okay, God. Sure, you are there in the obvious sacredness of gold and white and blue and red and black, in the triptych, or the altarpiece. Will you present yourself in pastel? Will you present yourself in the legal pad? Will you be there if I include a smiley face? What about paint-by-number paintings? Or, if the process is sufficiently meditative, quiet, and consistent, surely you will be there. It is easy to pray in the closet, to listen and be present. But what about those noisy moments when the mundane of life gets in the way?

In some ways, some of my choices were meant to make it more difficult to concentrate. I made a painting with a daily devotional book glued to the lower part and a big flower-power daisy above it with a smiley face in place of the capitulum. Can you do your devotional with a daisy smiling down at you?

JR: I appreciate your incredulity regarding the categories of "secular" and "religious" art. Still, many viewers in the Christian community give preference to work that appears to be religious or affirmative of their own religious convictions. Even in an arts organization, such as CIVA, there are many individuals who strictly equate Christian content with Christian subject matter and textual references, although this attitude is not universal. Do you find yourself

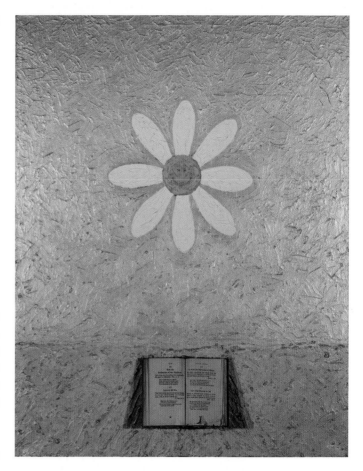

making concessions in order to make your art accessible?

GC: The book-page paintings, with *The Power of Positive Thinking* chapter titles using religious lingo, were somewhat of a way to connect my painting process (which was obviously religious for me) to something that

religious people would recognize. To this day, the paintings on the pages of *The Power of Positive Thinking* with religious chapter titles have garnered the most attention in CIVA.

Also, several other groups of works present a compromise, most often in titles, so that an audience would consider them religious. I found that some viewers often seemed to need textual identifiers to help them get the religious content. No relying on the Holy Spirit for this group. You have to spell it out. This experience, this reception of my work, was ultimately a bit disappointing.

JR: Some of your later work, such the paintings of legal pads or the paint-by-number works, were less overtly religious in their titles and texts, but they do still employ forms and methods that were intentionally devotional. Some of these legal pad or ledger paintings have religious titles, but others do not. How do you decided when to give a work, which is not evidently religious, a religious-sounding title?

GC: I confess that I have been guilty of changing titles so that the work might appeal to a Christian audience. For example, a legal-pad painting originally might have been identified as *Untitled* (*yellow painting #2*). When I entered it into a sacred art exhibit, I titled it *Moses' Tablet*.

My legal-pad paintings were consciously composed in cruciform, or altarpiece format to connect with a religious tradition. Otherwise the religious audience would not get it and

turn away. The paint-by-number paintings were painted with the same prayerful attention, were just as religious, but I wanted to stay away from traditional Christian imagery in order to re-establish the point of the process—process being my paying attention, being present prayerfully, regardless of whether the imagery was traditionally Christian.

In the long run, the spirit of the work is what makes it religious. For example, I saw Tim Lowly's paintings in 1981-82 before I knew him. I sensed that there was a spiritual connection with him. I later discovered that he was a Christian. On the other hand, there are constant reminders of art made by "Christians" that does not feel right to me. It may feel right to someone else and be spiritually uplifting for them, but not for me. I can't deny the truth of their experience, but it is just not the experience that I have been allowed to have or connect with.

VOCATION

JR: After graduating from Bethel College in 1977, how did you get started as an artist?

GC: When I finished college, I cleared out my studio and moved back to California. I had mainly these words from a mentor, David Abel Johnson, to think about: "You can handle the form. Now you need to work on content." But I didn't know what content to address. So I prayed. My prayer was, "What should I do?"

JR: You prayed about what you should paint?

GC: My spiritual life at that time was very traditional. I had a very literal view of my faith—evangelical Christianity. So I literally asked God to show me what to paint. God said, "Paint, work, and wait." Or that is what I imagined I should do.

JR: What did you discover from this process of prayer?

GC: The painting process itself became a kind of prayer. I started to realize that my prayer wasn't very focused, that I needed to listen rather than talk in my prayer. I tried to set up a process that quieted my mind but kept it focused. I am not saying I was very good at this.

I realized that I was bringing more to the table than I thought; my own assumptions, definitions, my own creativity, personality, etc. influenced the choices or creativity. At that time I didn't think I could trust them. So I tried to construct a process that was less of me and more listening and waiting, more paying attention.

JR: So, one of the issues of your artistic development at this time was a search for "content." What content seemed open or closed to you at the time?

GC: When I started painting after college, I saw a myriad of viable messages being expressed by the art of the time and by the art in history. They all seemed good or possible. Choosing content was daunting. To choose one direction over another seemed counterproductive, or at least that is how I felt at the time.

My professors at Bethel College had, more or less, "forbidden" us from making overtly Christian art, I think because it seemed so cliché. But they encouraged us to work out our art "in front of God." Dale Johnson once recommended actually laying hands on our paintings in prayer.

So I prayed for guidance. Then, believing that God had led me to that place in time, prepared me to be an artist and specifically to be a painter, it seemed that I should paint, and work and wait to see what came. I started with a rudimentary definition of painting. I covered a surface with color. Everything evolved from there.

JR: How did you take this inspiration and actually get to work as a painter?

GC: Painting, or covering a surface with color, was work to do while waiting for inspiration, while waiting for guidance. I would work, concentrate, pay attention, be available, and see what happened. A lot of the direction I took was an effort to make sure that I wasn't imposing my own will on it, my own content or imagery. I tried to work with givens, use what was inherent in the media, in painting, etc.

JR: What you are describing sounds like an attitude of humility and love in approaching the materials of your art. Is that right?

GC: I thought that John the Baptist's statement

UNTITLED
(FRUIT OF THE
CRUCIFIED LIFE)

1987
ACRYLIC ON
BOOK PAGE
9" x 12"

about Jesus: "He must increase. I must decrease" was the way to go. I didn't think so much about love and humility.

JR: If you work with an attitude of not imposing yourself onto the work, how would you describe your approach?

GC: I set up a system, a process, and see it through. While I work filling a surface with color, I am expecting, waiting, listening, hoping for some connection, for some revelation, some divine intervention, some evidence of logos incarnate. When or if something emerges from this listening prayer activity, it heals me, inspires me, uplifts me, hopefully making me a better human being, more polite, more generous, more patient, more loving. That's the idea, anyway.

JR: If the working process is one of waiting, listening, hoping for divine intervention

GC: God is the inspirer, the breath giver, the

one to whom I look or listen. In the process of artist-as-listener, I start with working, with painting in its most mundane form, or I did when I began merely covering a blank space with color, repetitiously, in 1978. I realized that I had been brought up, prepared from an early age to be a painter. But I didn't know what to paint, or there were so many things one could paint, I didn't know what would be authentically mine.

JR: If the artistic process is devotional, what happens to the work when it goes out into the world?

GC: If the work heals me, saves me or enables me to keep going, a power beyond me presents itself, maybe beauty presents itself. Then, I do feel a duty to exhibit the work for other people, in case they are in the same place as me, or not, but perhaps one person may be so inspired, attentive, ready to discover some healing presence or at least know that someone else (me) is in the same place as he/she and maybe not feel so alone.

PAINTING AS PROCESS

JR: The transition from undergraduate school, which is often assignment-driven, to the freedom of the studio can be personally difficult for many young artists. Often there is no one else there to give you direction or critique. Additionally, you were making this personal change at a historical moment, in the late 1970s, when the art world was in a bit of a transition. The last movements of modernism had clearly become academic,

and the plurality of what was being called post-modernism was an open field of problematic possibility. Even the name "postmodern" suggests that people didn't know what was going on; they just knew that it wasn't modernist anymore. Besides praying, how did you actually go about working out these options in your art?

GC: Everything was available to me, but choosing any one direction seemed to deny the others. This was the beginning of my reductionism. I started thinking about clearing out everything except what was most basic. I got the sense that I had been prepared from a very early age to paint, not to sculpt or anything else. So I started with some basic definition of painting . . . filling in a surface with color. I would do this as I continued to pray for direction, subject matter, or imagery. My process was reductionist. This reduction of creativity, or creative input, worked itself out in several ways. I would try things, things I felt led to do. Sometimes I understood what I was doing and sometimes I did not.

Anyway, what I am trying to say is that the reductionist search for essential, minimalist, modernist me was exposed even as I was searching for an art that would be pleasing to God, or a ministry to others. But I really did not know what that would or should look like.

JR: By eliminating what was "unnecessary" from your art, you were reducing it to its essential unity of content and form. This was a big risk, especially for a young artist, because as you eliminate

elements from the work, each element that remains becomes amplified. That can be a positive thing, but it can also be a disaster. There is no moderation or mediocrity in minimalism. The work, such as painting of a single field of color, either hits or misses; the middle ground, which is the safety net, has been eliminated. Was that move to minimalism a risk that you calculated?

GC: The move to reductionist minimalism was a bit radical for me. Eliminating all imagery, the paintings looked like color-field painting, all over compositions with no focal point. It made sense to me but I hadn't planned to be quite such a minimalist.

I got some validation for doing this from an article, published in the September 1978 issue of *ArtForum,* by Marcia Hafif, titled "Beginning Again." This essay helped me see what I was doing as a valid art approach. I needed that because the minimal, imageless field that resulted was not easy for me to accept at first.

JR: This was a particularly critical time for contemporary painting. Your art is often very multimedia, but you are still very much a painter. How is your art concerned with the language and state of contemporary painting?

GC: Yes, one of the dominant themes in my art has to do with what painting is: painting as covering a surface with paint; painting as interaction of object and illusion, surface, and space, etc.

But more basically and personally, I looked back on my life and decided that I had been heading in a direction, had perhaps been training for a profession, from as early as kindergarten. My parents were very encouraging of my art. I had been prepared as a painter because from my earliest memories with art, all were associated with painting. And since then, one of the dominant themes in my work has been painting—its definition, process, and material.

I realized that I was a painter. So I made my work about painting. I try to stay on that path. I look for other things to do, other imagery, waiting for it to present itself as something important enough for me to address. But the work is usually always about paying attention to the brush across the canvas/paper/surface. I need texture to make the painting process visually manifest. I like to show the paint, and paint is material.

JR: How does this process of painting as a medium of "paying attention" translate into the visual themes and motifs of your art?

GC: Of course it happened over time, with a lot of things going on in my life. I guess there is a question from which most of my work grows. That is, "What qualities are necessary and sufficient for transforming the material of a painting into something meaningful, beautiful or transcendent?" Is this a theme? It is my process.

JR: If the question, "What qualities are necessary and sufficient for transforming the material of a painting into something meaningful, beautiful

or transcendent?" is central to your art, is that related to a question such as "What qualities are necessary and sufficient for recognizing and responding to the presence of God in any particular moment or situation?"

GC: Yes, in a way, it is pretty much the same thing. I prayed for God to use me and direct my work. What did I need to do? The immediate thought was to be attentive to the process. To pay attention.

JR: How did this issue of paying or praying attention manifest itself in your art?

GC: This has manifested itself in my work in two ways. On one hand, this has resulted in reducing the material, or imagery, to a minimum. The initial adjustments, back in graduate school, were to make imagery (lines) that forced me to pay greater attention to the filling-in process of painting. This turned into the watercolor grid paintings.

On the other, it has led me to try various impediments, or images that might work against that transformation. If paying attention was required, what sort of banal imagery, non-sacred imagery, might hinder that attention? In the mid-Eighties I started putting smiley faces on some of my book paintings and altarpiece paintings. It is easy to pay attention when the stimulus is limited. Distracting imagery forces one to pay greater attention. One of the motives behind the evolution of the work is to force me to pay attention when it may be difficult. Still, I realize that there is something strange at work here. I reduce my process to a minimum and work and wait for inspiration. What image emerges? The smiley face! It took me years to get over that.

HAPPINESS
TRIPTYCH
1989
GOUACHE
ON PAPER
11″ x 26″

JR: It seems that your art embraces clichés. In judo, one uses their opponent's strength against them. Clichés have their own strengths that can be used to undo them. What is your strategy of embracing clichés?

GC: It would seem that I was/am willing to embrace cliché when it fits in or aligns with the several overarching themes that are important to me. Hopefully, these clichés are transformed by the painstaking attention I give to the process laid on top of them. If I worry about clichés, it is a worry that the transformation or transcendence will not be achieved. It is a worry born out of the countless failed works that either no longer exist or are hidden from most people's view.

JR: What relationship, intentional or not, do you see between your own reductive process and apophatic philosophy/theology?

GC: The apophatic tradition is the way of negation. It is the way to truth, goodness, and beauty through eliminating all but what is essential. The process of elimination allows one to test to see what is essential: "Can I live without this color, this shape, this paradigm?" I pare away assumptions to see which ones are essential. The idea is to get a clearer picture of God by paring away the things that are not God. It sounded like a good approach but it has its contradictions. Not the least is the question, "What is not God?" The opposite tradition embraces all things as from God—the way of affirmation. The desert mystics followed the way of negation, pursuing pure, simple, and even abrasive lifestyles. St. Francis is my example of the way of affirmation, embracing all things as good gifts from God.

Much about my personality and therefore my painting process is attracted to the way of negation, always remembering that the way of negation is about getting to what is essential. Ultimately I agree with Charles Williams in *The Descent of the Dove,* that health requires a balancing of affirmation and negation. Moving to an extreme in either case, gluttony or starvation, is destructive.

JR: How did you develop this understanding of the apophatic tradition?

GC: I had described my reductionist approach to painting to Ted Prescott in 1985 while showing him my book paintings, when he recommended *The Descent of the Dove: A Short History of the Holy Spirit in the Church* by Charles Williams. He is the one who introduced me to the apophatic tradition.

UNTITLED (ALTAR
WITH LADDER
AND FLAME)
1987
WATERCOLOR,
ACRYLIC AND
INK ON PAPER
30" x 22"

THE ART OF **GUY CHASE**

JR: Is there a seminal work or body of work that was the genesis for the rest of your art?

GC: Most of my work continues to grow out of a time between college and graduate school. The main trajectory of my oeuvre is a more or less logical evolution from one body of work to the next. There are a few works that don't fit neatly, but most of the work does, at least in my mind. The whole thing started with the oil-pastel color fields.

JR: Much of your work from the period just before and during graduate school employs some form of grid. How did that visual motif develop in your art?

GC: When the grid appeared in my graduate school painting, I knew it had been used and overused and was not taken seriously—by myself especially. The use of the grid structure so easily organized otherwise chaotic work that it seemed every artist in the 1970s incorporated it in one way or another. It was formulaic. But, I had to use it, or more precisely, it used me. I don't know if I can make this clear, but I wasn't painting a grid. I was painting rectangles side by side. Each rectangle was simultaneously a painting in and of itself, and a simplified, symbol of the mark of the brush. In my effort to find a process that required as much concentration as possible, I needed to set the rectangles as close as possible, leaving only the finest line of raw paper

in between. In the end, the grid appears. It's like in Piet Mondrian's painting of the tree, where he doesn't paint the tree but he paints the sky between the branches. The tree is what you see, but he painted the sky.

JR: What was significant for you about painting rectangles, which were concrete forms, rather than a grid, which is an ordering system?

GC: I paint rectangles. In the end it looks like a grid. It is somewhat like writing. I start in the upper left corner and work across to the right and then return to the left to go again. Each rectangle is drawn and filled in as a separate entity. The grid swells and sways; it is irregular. But it is an ordering system, organizing my concentration.

I don't know if I distinguish the rectangle and the grid theoretically. The distinction is more in process, in the action. I guess, to most people, this distinction is splitting hairs. Even so, I felt I had to own the grid, to make it my own and somehow transform it.

JR: I think that there is a real and important distinction to be drawn between, on the one hand, a structure or theory, the grid, that is born from a real substance, the rectangle, and, on the other hand, a substance or form that is born from, and thus is determined by, a given structure or theory. Is this painting of rectangles, not grids, your strategy of allowing a process to unfold organically in time, without the imposition of your own choices onto that process?

GC: In much of my work, the elimination of choices, allowing for much of the creative work to be predetermined, can be ascertained. I usually start with a predetermined process, system, or structure. I attempt to follow it as carefully as possible. What is revealed, over and over, is my inability to perfectly follow the process, to fit the predetermined plan. The aesthetic that emerges is based on failure. My mistakes are the most interesting parts. But, I don't set out to make mistakes. Most of the time I am sincerely trying to pay attention.

JR: You mentioned the grid appearing in your graduate school painting. What years were you in graduate school at the School of the Art Institute of Chicago?

GC: From 1979 to 1981.

JR: What did you gain from your graduate school experience?

GC: I have the propensity to make formulaic art, art that fits neatly into a kind of designer mentality. Mats and frames, paintings under glass, nice art-store materials. In graduate school, when I was making the color-field works with oil pastel, I neatly masked off the square with a mat-like white border around it. I made ten of these, and when they hung in a row, you could easily see them hanging in a nice hotel lobby. I was criticized for that quality. Another criticism I heard tossed around was also aimed at a formula using what were

called "art marks." These were usually scribbles or drips that didn't seem authentic. Add a scribble to an otherwise pristine, organized work and it gives the air of creativity. The issue of authenticity stuck with me.

I subsequently tried to avoid the look of art, at least in the late 1970s and early 1980s by trying to use a ground for my painting that wasn't an art material or a material conventionally used or bought in an art supply store. At one point I started painting on craft paper.

This also relates the institutional definition of art, because if you use conventional materials, materials that are usually found in art museum works, or art supply stores, it is more likely, supposedly, that your work will look like art. It is also an exercise in creativity to work with unconventional materials.

So, all this fed into my decision to use book pages as the ground for my painting. After the book paintings, I tried cardboard and ashes mixed with acrylic medium as the paint. Before I made the legal-pad paintings I was using a legal pad as a sketchbook, and then used the legal-pad paper as ground for paintings. I never made archival-ness a priority.

JR: How did your work evolve from there?

GC: The work I did in graduate school charted a course from the color-field oil pastels to the watercolors. This followed a logical progression, as I was searching for a way to force my concentration onto the activity. The result was to paint one small rectangle and then to paint

another as close as possible and as much the same size as possible. Each rectangle was a small painting. Setting many side by side produced the grid. But I never painted grids; I painted rectangles.

It is ironic that in my most recent work I am finally painting or drawing grids. And it is a whole lot easier than painting the rectangles!

JR: In establishing a working process or methodology, how were these rectangles significant?

GC: Painting rectangles side by side forced me to concentrate. The rectangles paintings were a result of the process of simply painting and waiting for inspiration. I eventually grouped different grids together in lists or collections. When I started the book-page paintings I was simply using the page as a context on which to paint another group of rectangles. Eventually the process evolved with the books so that it interacted with the format of the text, the words, or the spaces

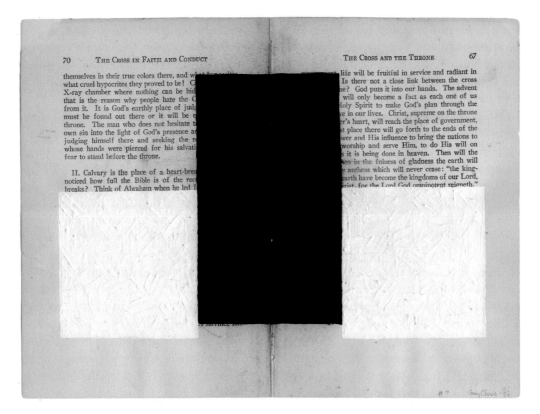

between the words. The process was still meticulous and meditative. You can see this work in the watercolor paintings and then the book paintings that still retain the grid structure. And then the other book paintings that veer off of the rectangular grid.

BOOK PAINTINGS

JR: What was your first book painting?

GC: The first book I painted on was Norman Vincent Peale's *The Power of Positive Thinking.* There are a couple of reasons I chose this book, besides the poignant chapter titles. First, I was present at the inception of the now mega-church Willow Creek, and Willow Creek's Bill Hybels was inspired by Robert Schuller, who was inspired to positive thinking by Peale. So, it was something on my mind. Also, while I was a student at Bethel, there was a protest against having Schuller speak in chapel. I began to question the ideology of a positive thinking that led to affluence and the gospel of prosperity. So, I had a love-hate relationship with the book.

JR: The tone of your art is often upbeat, paintings on pages of Norman Vincent Peale's *The Power of Positive Thinking,* but your method is one of skepticism and reduction. How are these reconciled?

GC: Sometimes, I think my work all comes out of depression. Remember Robert Crumb's older brother Charles? I think about his books filled with writing that turned into scribbles

as page after page got filled. I am inspired by his work, its eccentricity, its devotion, and its necessity. Do you really think it is upbeat?

JR: Maybe "upbeat" is the wrong word, but I do find your work to be "uplifting." Do you see an uplifting or hopeful element in your work?

GC: To me, the hopeful or uplifting part of art is always in the continuation, the attentiveness over time. The breathing continues. I have been skeptical. Most of the work grows out of a question. I question something that I assume to be true, whether in art or religion. That's skepticism, but that skepticism is important to my religion. It is the pursuit of truth, of God, in front of God, with God. That is uplifting too.

JR: In a pursuit of God, can skepticism be a positive strategy?

GC: Whereas some people think they are backsliding when they begin to get skeptical, I saw it as part of my growth journey, all happening in front of a God who never leaves and is always present. Somewhere in there, I felt that God had given me a brain and wanted me to use my brain, so I gave it back, figuratively speaking, and rarely felt that my thoughts were not inspired by him or the Holy Spirit.

Well, there have been a lot of thoughts that weren't, but those are mostly reconciled at some point in my personal prayer life or are in the process of being reconciled.

JR: How does your art embrace contradiction?

GC: I try to eliminate contradictions, knowing that some basic ones are always present. Contradictions within my own work pose problems that I hope I do not neglect. In some ways, the quest in the work is to maintain consistency, to make no claims that are unjustified, and to raise questions when uncertainty rears its head.

JR: Is there an "integration," a popular word in Christian academia, of skepticism and faith?

GC: I had the suspicion that people who felt the need to promote the integration of faith and learning must start from a point of disintegration. In all my faith, upbringing, studying, and experience, the goal was to live through Christ in all things. The goal was to see all of life as worship, as prayer, as lived out in relationship with God. So, I don't integrate

UNTITLED BOOK PRINT (THE NERVOUS BREAKDOWN 246 & 243)
1985
ELECTROSTATIC PRINT ON BOOK PAGE
8″ x 10.5″

skepticism and faith, and I don't disintegrate them either. They must be the same thing.

JR: When did you begin painting on book pages?

GC: By the fall of 1982, I had painted a good number of pages from *The Power of Positive Thinking*. Most of the pages from that book were painted in 1982, but I continued to use pages from that book into 1983, and once in a while in the subsequent years would paint or draw on the remaining pages.

I painted a couple of paintings on pages from that original *The Power of Positive Thinking* book a few weeks ago. There are still several unpainted pages left.

JR: When did you begin to paint on pages from books other than *The Power of Positive Thinking*?

GC: In 1983, I began painting on a novel titled *Time and Time Again*. The majority of those paintings were more like lists or collections of paintings, where I used the paper of the book to paint "test" grids or painting processes, marks, doodles or spills. I also started to work the grids into oval or egg shapes, celebrating or identifying that form, as my wife was pregnant with our second daughter.

The third group of book paintings started after my 1984 show of *Power of Positive Thinking* book-page paintings at Timothy Burns Gallery in St. Louis. They were on pages from a book titled *Christ and His Cross*. The last series was on the book *The Cross in Faith*

and Conduct. I chose these books because I was considering a more overt connection of my painting process with a Christian idea of listening prayer.

So, I've made book paintings off and on for many years, using a variety of books.

JR: Were the paintings on book pages your first works out of graduate school?

GC: That is close to true. I continued to paint watercolors. I worked on compositions with groups of paintings on a single sheet with marginalia. The work changed slightly with the addition of color, first rather subtly, and then color became more exuberant. But that was later.

The book page paintings started toward the end of 1981. I think we did Christmas in the Chicago area with my wife's family and I went to a Salvation Army store looking for a book to paint on and found an early edition of *The Power of Positive Thinking.* I was drawn

to the chapter titles, which were both serious statements and terribly cliché: *Try Prayer Power, How to Use Faith in Healing, Believe in Yourself, How to Create Your Own Happiness.* I was becoming more and more critical of my own faith. Not to the point of giving it up. More like an insider who doesn't like the way things have been organized, or who is unhappy with the people in charge.

JR: When you began to exhibit these paintings on book pages, how were they received?

GC: The first group of book page paintings was shown in 1983, in Louisville, Kentucky, and then in St. Louis at the Timothy Burns Gallery. A reviewer called them another version of pattern painting. I remember being irritated by that. In the next book-page paintings, I gave up the careful painting process and focused on blackening the text block with charcoal and india ink. I started, thinking

I would simply blacken all the text blocks in the whole book, but as usual I began to vary the approach and started doing all kinds of things, like erasing the text and Xeroxing my face in the text.

ALTAR PIECES

JR: From the book-page paintings, how did you begin the altarpieces?

GC: I was pretty much done with the first group of book-page paintings when I started working on the altarpiece paintings. The first altarpiece paintings were cut out of 3/4-inch particle board using a band saw. They were carved with an indention for the imagery like an icon. I had been thinking about my watercolor painting process, where I increased the amount of water in each rectangle to increase the effect if I made a mistake. If I got too close to the previous rectangle, the color would explode into that rectangle by capillary action, accentuating the mistake. Then, in 1983, while using an IBM correcting Selectric typewriter, I began thinking about the corrective ribbon and how it documented mistakes. So, I collected corrective ribbons from office secretaries and used them in the early altarpieces.

I continued to work on book-page paintings at the same time I was working on the altarpieces.

JR: How did this altarpiece series develop?

GC: After I stopped working on the paintings

ALTAR FOR TWO DAYS' DEVOTION
1987
GRAPHITE, GESSO,
NEWSPAPER,
WOOD ON
ALTERED
CIGAR BOX
13" x 10" x 4"

on the pages of *The Power of Positive Thinking,* I looked for another format for my painting that might locate it in a devotional context or in the history of Christian devotional art. I visited the art collection at St. Louis University and saw some wonderful portable altarpieces that were several hundreds of years old. They showed definite evidence of use with aged and cracked paint, worn-out hinges and latches and surfaces. I was inspired by the idea that here were signs that indicated someone had spent time praying in front of these objects. I was less interested in the paintings' imagery.

JR: You recognized that these works were sacred not because of their imagery but rather because of their presence. How did you translate that recognition into your own art?

GC: I started to construct painting shapes reminiscent

of those with arches and pointed arches in three-part panels. Although I had been struck by the marks of wear, I decided that I did not want to make paintings that looked like they had been used hundreds of years ago. I did not want to fake the look of devotion. I stayed away from nostalgia. It was important to me that the devotional aspect was for a contemporary meditation or listening prayer.

JR: Why didn't you want the "look" or surface appearance of devotion?

GC: I have always suspected religious art that looks "antiqued" as if for an old-fashioned religion. A similar sensibility arose confronting the work of Howard Finster. I saw his paintings shown several times in Chicago at Phyllis Kind Gallery. The secular reception of his flagrant

**UNTITLED
(LEGAL CROSS
PAGE TRIPTYCH)**
1989
GOUACHE
ON PAPER
14" x 25.5"

THE ART OF **GUY CHASE**

condemnation of sin was mildly shocking and a bit funny. But then I realized that his religion was seen by the art-gallery audience as quaint rantings of an eccentric throwback to an ignorant past. I wanted to make art that grew out of my own living, current, and personally devotional faith. It shouldn't look old-fashioned or dated.

JR: How would you describe your own relationship with art history? Do you see your own work as being connected to art history?

GC: Yes. In an art history class at Bethel College, the professor, George Robinson, asked if any of us thought of ourselves as artists participating in the dialogue of art history. I thought for a moment and raised my hand. That is when I realized that I wanted to try to play a part in art history, megalomaniac that I am.

JR: What does it mean to play a part in art history, particularly the history of Christianity and the visual arts?

GC: From a modernist art historical perspective, a progressive dialogue occurs from epoch to epoch, or between one artist and another over time. Contributions are made, almost like hypotheses. Response is given, restatement and counter statement. The way art history was taught when I was in school set it up as a dialectic. I wanted to contribute a response and perhaps a hypothesis. As I studied the history of Christianity and the visual arts, various

periods and places inspire me, such as medieval church architecture, illuminated manuscripts, icons, or altarpieces. I appropriate these elements from the Christian tradition in art in my own work and hope they may connect to an educated Christian audience.

I also studied mid-nineteenth century painting, French realism and impressionism, which may be better understood as the beginning of modernism. My interest also extends to early abstraction, Pablo Picasso, Piet Mondrian, Kazimir Malevich and then to Jackson Pollock, Ad Reinhart, Phillip Guston, and Jasper Johns.

LEGAL PADS AND FILE FOLDERS

JR: Jasper Johns may be one of the seminal artists of the second half of the twentieth century. His work of the mid-1950s transitioned from modernist abstraction to all of the significant art movements of the 1960s: pop art, minimalism, process art, conceptual art, etc. What did his work mean to you?

GC: I was intrigued by Johns' idea of painting a flag that wasn't a picture of a flag but was a flag itself. A painting of a symbol is still a symbol. I thought about that question with my legal-pad and ledger paintings. Although they weren't symbols, they were both representational and abstract paintings. The work of art's dual nature is an important visual theme in Johns' art, such as the vase/face image.

In the late 1970s, before I arrived at the rectangles, after doing the oil pastels with the random marks, the marks evolved into a

kind of cross hatching, covering the surface in a more conscientious fashion. These ended up looking a lot like Johns' hatched paintings from the seventies. So, I spent a lot of time looking at them.

As Johns' painting became more complex with inner narratives, self-referential histories, and quotations of Matthias Grünewald's *Isenheim Altarpiece,* I became less interested, even a bit perplexed but still engaged. Then, when I did the Sudoku paintings, I used those late works by Johns to justify my own addition of images in the margins, to complicate the story. I have been looking at his work all along. He is perhaps the most influential for me. That he continued to make his own work, let it be obscure or mysterious, and seemed to continue to grow out of inner need, late in his life, is also a profound inspiration.

JR: This tension between being a painting and a flag is, in my opinion, profound. Since the early Renaissance, Western art had been pictorial. Even cubism and abstraction is pictorial. Jackson Pollock allowing his paint to drip as just paint, as well as his allover compositions, was the first real break with pictorialism in 700 years of painting. But Johns established a new form of literal art. A painting by Rembrandt van Rijn, Pablo Picasso, or Jackson Pollock opens up spatial depth that moves away from the viewer. In Johns' *Flag,* there is no spatial depth; the image is purely material. It is a painting that literally exists in the same space as the viewer. Is this distinction between pictorial painting and literal painting meaningful to your art?

GC: This runs all through my work. Sometimes this is on purpose, as in *Actual Things* and *Realism Plus,* sometimes as a matter of course, as in the legal-pad and ledger works, and perhaps in the paintings on icon pages. The connection with icons relates in interesting ways to the dialogue: icons as pictures, as symbols, as presence, and as word.

JR: How did these legal-pad and file-folder works fit into your art's thematic evolution?

GC: The legal-pad paintings were reductionist minimalism in several ways, but they provided the banal and blank images that were antagonistic to overt meaningful, beautiful or transcendent sentiments. My previous work had moved toward the use of stereotypical "spiritual" color, like gold, white, black, and red. I had been contemplating using pastel colors to see if they would work against transcendence.

The lived experience of sitting at my desk needing to write a letter, a memo, or a lecture, finding myself staring into the yellow paper, through the blue and red lines, into a deep space, in a sense, praying for inspiration. There was the contrast between an emphatically flat pastel plane material and the inward-searching blank stare into space that merged and made the moment a sacred one. The paintings which organize the legal pad paper into an altarpiece, triptych are meant to commemorate that prayerful moment of inspiration. On the other hand, the paintings

draw Agnes Martin's grids into the everyday banality of the legal-pad paper.

JR: How is the content of these legal-pad and file-folder works devotional?

GC: Through process. They are hand-painted—carefully, meticulously painted. What is not readily seen in reproductions is the texture of the paint. I think that when a person looks carefully at the work, it can be deducted that the lines were drawn first and then the yellow was painted around the lines. So it is not just the image but also the process of making which I am providing.

The file folders are different in that they are more about the image than about the process.

JR: In 2001 and 2003, a bit later in your career, you also did a series of ledger works. How do the ledger works relate to the legal pad and file folder works?

GC: I think, in the obvious way that I am making a painting that looks like something—ledger paper—and yet does not illicit the illusion of space. It is not pictorial. I considered painting ledger paper at the same time that I did the legal-pad paintings.

I was interested in them because of the grid form, which had already been part of my art, and because of their proximity in my life, since my wife was an accountant and the ledger paper was part of her work in the 1980s. But it didn't have that personal moment of prayerful attention that was part of my experience with the legal paper. And painting all those little rectangles intimidated me, especially because I didn't have more of that personal connection with the stuff. So it wasn't until I was in Charlotte, North Carolina, a big banking center, after the Enron scandal broke, that it started to make sense to work with ledger paper.

Also, the fact that, as a professor at a Christian college, I was required to do productivity accounts, to chart my productivity, and I started to see how adjusting the numbers got other people advances that were not otherwise valid. I became quite cynical toward those business-oriented number crunchers who were in control of the art department. At that point I started to have a personal connection to the pale green grid. Altering the ledger-paper grid partly draws attention to the way numbers can be arranged to make whatever point you want to make.

JR: Some of the titles of these ledger works, such as *Untitled* (*ledger for a last judgment*), *Untitled* (*ledger for multiple adjustments*), *Untitled* (*blank page from the book of life*), and *Untitled* (*ledger for a final accounting*) suggest themes of working out one's faith in fear and trembling (although the meticulous nature of your art allows for very little trembling), or freedom and responsibility. In these ledgers, there is a sense of determinism.

GC: Probably not any more than in any of my other work.

JR: Are questions of free will and determinism ones that you have thought about?

GC: Again, I set up a process or a system that I attempt to follow as carefully as possible. It is predetermined. But my ability to fulfill the process is always lacking. The themes of free will and determinism emerge from this conflict.

Between college and graduate school, from 1977 to 1979, I worked as a groundsman mowing lawns for an elementary school district. The job impacted me in a couple of ways. One way is that it made me question the value of what I was doing and showed me a way to value it that was transferred to my art. An artist on a lawn mower might cut cute designs in the grass. I realized the value was more practical. An efficiently cut lawn was safe for children to play on and should take as little time as possible. My integrity was expressed not by decoration but by straight parallel lines, cutting the grass as efficiently as possible. The process revealed more

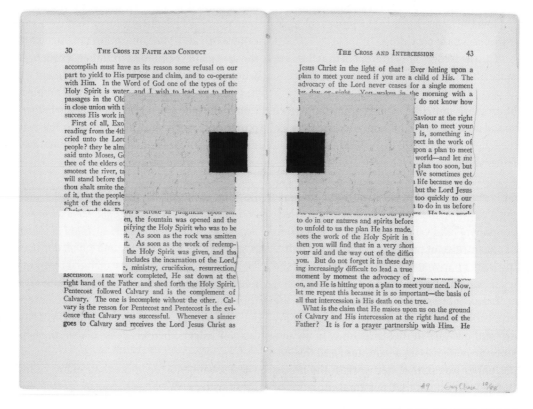

UNTITLED
BOOK PAINTING
(TCIFAC 30 & 43)
1988
GOUACHE
ON BOOK PAGE
7" x 10"

THE ART OF **GUY CHASE**

about me than the end product.

JR: I find that when I'm doing work in my yard, like mowing the grass, that my mind is often cleared in a way that I can think about things. Some my best writing has been in done behind a lawnmower, rather than behind a desk. Was that your experience?

GC: It was a pretty fertile time. The job gave me time to contemplate things. I had read, in a course on the book of Romans, the book by Jonathan Edwards: *The Freedom of the Will.* I decided to work on the problem of free will and predestination while cutting the grass. I discovered that I could barely concentrate for a few minutes before my mind was elsewhere. I am sure that I didn't add anything new to the discussion, but I considered the questions while marking a straight path with the mower.

JR: How were these questions manifested in your art?

GC: These questions of free will continue to have an effect on my painting. One of the most obvious, to me, is the watercolor diptych, *Untitled* (*grid with mirror*) of 1981. The left side was painted with a system which forced me to choose between vertical or horizontal rectangles. Every rectangle's placement was my choice. The right side contained basically one choice. I chose to make a mirror image of the left side. On the right side, the location or orientation of the rectangles was predetermined.

Then I noted the difference in the feelings I had as I painted. The left side with all the choices was more stressful. The right side was much more relaxing, almost freeing. The use of mirror images was taken from my study of illuminated manuscripts. They give the artist a distinct plan to follow, and that predetermined plan frees the artist from certain responsibilities, from introducing creative or imaginative additions. In almost all my work there is a similar predetermined plan to follow. If not a mirror image, then it is the paint-by-number system, or the grid structure. There is always a bit of a dialogue between what is planned or predetermined and what gets in the way of the plan—which I usually call my humanity. That is, my inability to stay consistently within the lines.

JR: What side of the free will-versus-determinism debate do you come down on?

GC: I come down on the determinist side of the argument. But the sense of freedom of choice is important as well. Asked if I believe more in freedom or predestination, I reply with something of a joke: "My great-grandfather believed in free will. My grandfather believed in free will. My father believes in free will. My whole family has always believed in free will. So, I have no choice but to believe in free will as well. But the more I thought about it, studied it, and considered all the options, I realized I had to choose for myself. So, almost on a whim, I decided to go with predestination."

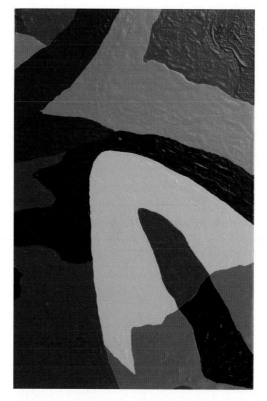

PAINT-BY-NUMBER AND SUDOKU PAINTINGS

EAR OF BUCK,
POISED AMIDST
GIANT RACK from
REALISMPLUS
2004
OIL ON 30 PANELS
9" x 7" EACH

JR: Another series of works that seems to address this question of determinism is the paint-by-number paintings. Working from a set, all the colors and areas for the colors are given. You simply paint according to the kit's instructions. At the same time, embracing those instructions and faithfully fulfilling them is no robotic task.

GC: When you reduce it down to the least amount of personal involvement (the fewer choices, minimal creativity, just follow the rules), there is still, or maybe just the human part or the spirit part. It is not robotic. What is left is what is most important. That is the task of reductionism, to get at the essential. With paint-by-number kits, creativity isn't much of an issue, at least in the traditional sense of creativity being imposing one's will on the stuff, putting one's ideas forth. It's all spelled out for you.

JR: In your "Statement for Actual Things with Their Own Color," you describe how your paint-by-number works grew, in part, from your doing paint-by-number kits with your daughter. However, there is not a necessary connection between that experience and your doing paint-by-number works as "art." Presumably many artists do paint-by-number kits with their children without this having any effect on their art. What motivated you to make paint-by-number paintings?

GC: Again, it was the process. Painting a paint-by-number kit well required the same concentration and care as all my other painting.

I was irritated with Christians requiring Christian symbols or biblical narrative in their art in order for it to be seen as "Christian." Most of my response was directed at my experience in CIVA. I went to a lot of CIVA conferences, heard a lot of speakers, saw the juried shows and walk-in shows, and, for the first 15 years, I went to the "late, late show" religiously.

There was no overtly Christian imagery or text in my watercolor grid paintings of the

early 1980s. That overtly religious element was first introduced with the book-page paintings, in the chapter titles. Even though the process of the book-page paintings remained the same (prayerful and meditative), in some ways, the book-page paintings were a compromise to make the process accessible. All the effort to find a religious symbolism to set the work in a Christian context was aimed at CIVA, and it worked.

Some people always like the easy stuff, the stuff with recognizable imagery or symbols. It tells them what to think, what to believe. And they don't have to look very closely. And then, when they embraced my work, it seemed important to make the point again that the painting could be religious even when there were no Christian symbols or text or narrative.

JR: One of the things that I most admire about your work is that the content and process are inseparable; they are one and the same. Did the paint-by-number kit suggest another of devotional content/process?

GC: Back to a process of reduction—I was eliminating whatever was from me (my training, my tricky creative imagination). In a sense, it was to eliminate the creative, so that I could be present to hear or see when God would be there.

In my early paintings, each rectangle was identical to the previous and the next. I tried to make each one as exact a replica of the first one. In aesthetics class I was interested in the qualities that differentiated the clone from

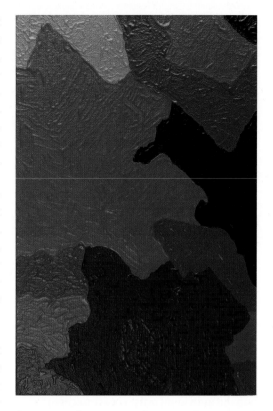

the original source. Why was the original more valuable? Sherry Levine, appropriating Marcel Duchamp, and others questioned the idea of the original. That is what I was thinking about in the aesthetics class when I discovered the work of Levine.

The paint-by-numbers, mostly, did not contain religious imagery but they required exactly the same meditative process. They were not about originality. They were about painting. They came from my own personal experience as a kid.

GRASSES AT BASE OF BIRCH TRUNK, FOREGROUND from **REALISMPLUS** 2004
OIL ON 30 PANELS
9″ x 7″ EACH

JR: How did the paint-by-number process address the issues of painting current in the early 1980s?

GC: When I saw the blue lines that delineated the images in the paint-by-number, I thought about layering imagery as did David Salle in his painting. Also, I thought about collage, or a collage technique of painting. All these seemed too novel, too tricky, not minimal or reductive (not that that was a conscious requirement).

I opted for vertical stripes. To me these were generic and had become a meaningless cliché of abstraction. And the colors were not my choice, and so optical effects were irrelevant. I had spent some time learning about icons and the icon-painting technique, but I was never interested in painting traditional icons. It seemed that paint-by-number had so much in common with the icon-painting process. You follow a prototype, creativity is discouraged, and the individual artist goes unrecognized.

I found a kit that was a triptych of horses. I painted it with as much care and concentration as I gave to all my other work, but I did not change a thing. I painted it according to the kit. Following the rules of the kit process seemed to me to be the same as following the prescribed process of the grid painting. In some ways, this work could be my most religious painting because I gave up all of my self in the making of it, all of my self except for my presence in the making of it.

I also painted a series of blue jays. They are minimal, monochrome paintings, painted with extreme care and time-consuming concentration. I painted the same painting ten times. One painting for each of the ten colors that came in the kit. The paint-by-number paintings tied together many of the issues I was concerned with.

JR: What motivated you to make paintings of Sudoku puzzles?

GC: As in most of my work, the motivations for making the Sudoku paintings were layered. But all the usual suspects were present: prayer books, meditation, illuminated manuscripts, monochrome painting, marginalia, determinism, and personal anecdote. These all lined up nicely to motivate me to make these paintings.

There was a personal connection in that I was using the Sudoku puzzles to keep my mind from veering into darker territory, depression, paranoia, or to just even off the roller coaster ride that was the relationship I was in. I was trying to escape from a very painful breakup. The paintings saved me a lot of money in therapy.

In a sense, working the puzzle was a kind of meditation. And, of course, meditation figures clearly in my work. When working a puzzle, there is tendency to doodle in the margins. Notes, unconscious markings, and conscious thoughts are jotted down. A few times after completing or ruining a puzzle, I would simply blacken it all in, covering the square puzzle box with black ink. A book of puzzles

would become a prayer book. It documented my thoughts, prayers, and lamentations.

The marginalia coincided with medieval illuminated manuscripts, which had been another interest connected with my own book paintings, and most of my previous painting.

JR: So, the structure of the Sudoku as well as the process of working out the puzzle were means of organizing or directing your thoughts in certain directions. How did the structure of the puzzle translate into the structure of painting?

GC: The Sudoku box is laid out in nine squares. When I filled it in with black ink, it resembled another of my longstanding interests. It tied it to Ad Reinhart, and then to monochrome painting. And, as in Reinhart's black paintings, there is a Greek cross revealed in the composition. Need I mention the fact that it is all laid out in a grid? The puzzle format is practically designed to be one of my paintings. The presence of all these interests would certainly be enough to motivate me to make the paintings, but as I contemplated the project, it became even more synchronized with my themes.

JR: In translating the puzzle into painting, how did you change the format of the Sudoku, such as enlarging the puzzle?

GC: I had the format, the page, the puzzle, and all that was growing with it. The decision to scan the pages and print them on a large scale was the tough one. Making things bigger for

Puzzle 52: Easy

the sake of art seems inauthentic. And that is how it felt. For me to do that meant that the paintings would have to have their own justification apart from what I've already discussed. Because all that is already there in the actual book pages. The paintings would start out as pictures of the pages, representations. In my mind, I am never a trompe d'oeil painter. I could have painted replicas of the pages, but again, that doesn't interest me.

The project of the painting was to fill in the areas around the lines and numbers so that the lines and numbers would become invisible,

UNTITLED
(SUDOKU
PUZZLE 52)
2006
GOUACHE ON
INKJET PRINT
ON PAPER
44" x 30"

MUST LOVE LIFE

installation

of 70 prints

2009

LASER PRINT

ON CRAFT

PAPER WITH

JUTE HANDLE

15" x 10" EACH

the context changes. The lighting, the angle of view, the texture of the paint, all contribute to varying the perception of the color. Eventually that task ran its course, and the color choices became mannered. In the end, the black, amorphous zone would create the sort of a space that one would find in a Mark Rothko painting. The paintings become analogues to the process. The process is meditative, and the resulting painting is a black hole.

JR: You mentioned earlier that, as the art of Jasper Johns became more personal, as it shifted from objects such as flags, targets, and maps to more coded content, it became less interesting to you. That is, until you began some of the Sudoku paintings. In the Sudoku paintings, you seem to embrace, or bring together, elements of both Johns' early and mid-career works.

making the square appear monochrome black or dark grey. The process is therefore the same as in most all my painting. I painted a coloring book in a similar fashion several years ago. That book has been lost, but the task of painting around the printed lines trying to match the black ink color was the one I was referring to with the Sudoku paintings. And so it is at this point that they become paintings. The painting process, the color mixing, the mark making, the care and precision all led to a perceptual process related to impressionism. It involved color theory, simultaneous and successive contrast, as the perceived color would appear different surrounded by the "black" paint that I added. In the first several Sudoku paintings you can see that I am adjusting the colors as I go, trying to get the right value and hue, even as my perception of the color changes when

GC: As my paintings started to recycle old themes and processes, I thought a lot about Johns. There are images incorporated into the Sudoku paintings that are added, that are cryptic but tie the paintings to specific occurrences and people that were important to me. I felt that Johns used imagery that had private, code-like meaning that wasn't easily interpreted. My introduction of Gospel-writer symbols has at least two levels of significance for me. And the image of the whale and the bird in three of the paintings relates to a Tom Waits song that haunted me during the end of the relationship.

JR: How did the Sudoku puzzle process relate to

prayerfully working these things out?

GC: The act of working the puzzle was a kind of meditation or prayer. I asked myself, "What is it a prayer for?" What benefit is gained, mentally, from working out the puzzle? Perhaps the prayer of the Sudoku is for wisdom—to see the interconnectedness of things, to see how choices influence outcomes. Each Sudoku puzzle should have only one solution. All the moves are predetermined. Figuring out the relationships that solve the problem requires one to fit into the plan. This connection to determinism or predestination drew me in further. The system or plan that emphasizes the process over the end product is also relevant, as in the paint-by-numbers, or all my painting.

JR: If these works are highly personal, even biographical, yet in a cryptic way, what happens when these works go out into the world and are encountered by viewers? How is the viewer to understand or get something from the work?

GC: I don't make my work so that other people will get something. I do exhibit my work so that some might get something. But, first, my art is for me, for my benefit. And I feel that my art is a gift to me, for my benefit, for my growth.

Some may say that art is completely self-indulgent. And, I guess, I would agree. But, in the end, that self-indulgence is really for other people in several ways. I think the work generates growth or a kind of healing, for me. And that growth or healing is important as I have relationships with other people. Hopefully it makes me a better person. Granted there are times when I wonder about this. Perhaps I will never know how bad a person I might have been without the painting. I just try to be true to myself, be honest with myself, and be loving and gracious. Painting helps me get at that.

If the work is good for me—that is, if it generates some growth or healing—then it might do so for someone else. But ultimately, it is not my responsibility. I can't make the work meaningful for people. That is the mystery. Since my own growth or healing is provided through this gift, this mysterious interaction, I suspect that if the work provides growth or healing in someone else, it will be equally mysterious, miraculous even.

My theory of communication is that real communication is a miracle. It really has little to do with the painting itself, and more to do with the memories or experiences that are brought to the viewer's mind, in some mysterious way, in the context of the painting.

JR: If you make the work for personal purposes, are the results for the viewer open-ended?

GC: You know, when I make my art, I don't really know if it will amount to anything for anyone else. It is just stuff I wanted to do, or needed to do. Sometimes it all seems absurd. But then again, I started by asking God to guide me. I shouldn't back off from the work that comes my way. Painting is my private devotional life with God.

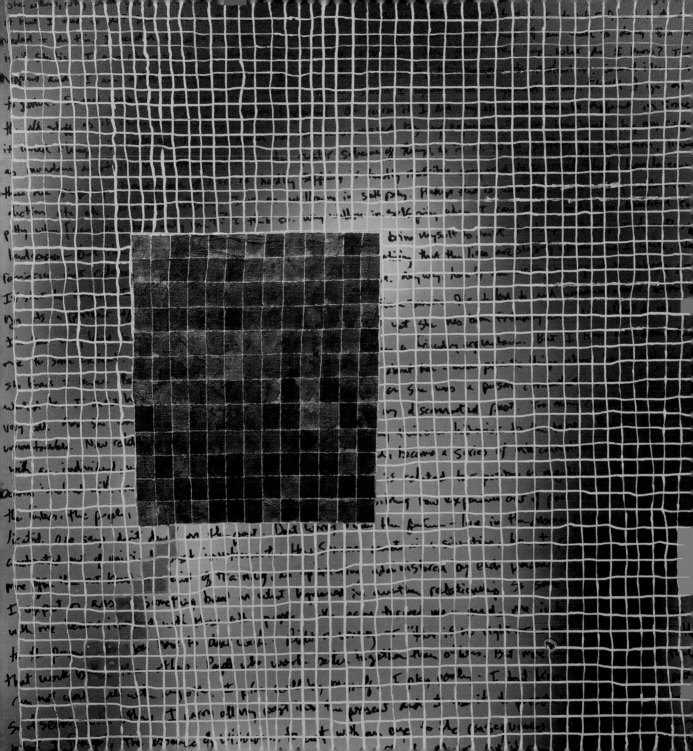

AFFIRMING ABSTRACTION

First Published in the CIVA newsletter, 1997

Architecture is essentially an abstract art form. Typically it does not provide a representation of images perceived in the physical world. Even though abstract, it still conveys meaning in a number of ways. Feelings may be evoked by specific forms. Symbolism, metaphor, and analogy can be used to supply multiple levels of meaning. Art that alters the representation of the physical world, even eliminates it, is also abstract. Since iconoclasm—the destruction of images—suggests a similar activity, it too can provide an understanding of some of the basic content of abstraction. A very broad interpretation of history in relation to art and Christianity shows that abstraction has played a significant role in our relationship with the spiritual. The aesthetics of Gothic architecture and the impact of iconoclasm bring that role into focus, undermining the notion that abstract art could ever be devoid of content.

In the 12th century, Suger, the abbot of St. Denis, attempted to influence an anagogic architecture that would glorify God and promote spiritual contemplation. He did so not by suggesting pictures or representations of biblical events and saints but by stressing form, light, and color. His Gothic cathedral symbolically expressed a reality of the spiritual through abstraction.

Thus when—out of my delight in the beauty of the house of God—the loveliness of the many-colored gems has called me away from eternal cares, and worthy meditation has induced me to reflect, transferring that which is material to that which is immaterial, on the diversity of the sacred virtues: then it seems to me that I see myself dwelling, as it were, in some strange region of the universe which neither exists entirely in the slime of the earth, nor entirely in the purity of Heaven; and that, by the grace of God, I can be transported from this inferior to that higher world in an anagogical manner.[1]

Suger's aesthetic expressed transcendent, otherworldly concepts by producing an ethereal interior space, accentuating the vertical, surrounding the spectator with either glowing colored glass or dappled light on stone. A Gothic interior is an inspired abstract installation, a site-specific environment, a stage set for a spiritual transformation. It is abstraction conveying spiritual truth—space, form, light, and color without regard to narrative, representational

OPPOSITE

HER CHARISMA

OVERSHADOWED

HER INSPIRATION

2009

INK, WHITEOUT,

WATERCOLOR

AND ACRYLIC

WITH INKJET PRINT

ON CANVAS

18.5″ x 19″

sculpture, or imagery. Here abstraction is embedded in our Christian, aesthetic heritage.

The whole of the "Dark Ages," the Medieval Period, roughly from 400 to 1100 A.D., seemed to deny the relevance of the physical world. All that was of value in the new Christian age existed in the realm of the spirit, especially since realistic representation by the Greeks and the Romans drew attention to the flesh and the physical. At one time medieval art was considered incompetent, degenerate, and barbarous by the classical standards embraced after the Renaissance. Some contemporary evangelicals, neglecting the art historical defense, recognize the similarities of that period with 20th-century abstraction. They draw the corollary and consider the art of our time a result of the denial of God and equally incompetent and childish. Modern art historians defend modern abstraction by validating the medieval use of distortion, stylization, and symbolic imagery. They ask, how does one represent an immaterial reality? How do artists represent what cannot be seen? An abstract, symbolic, visual language must be employed. If abstraction by artists of the first millennium was a result of a spiritual definition of reality, then likely, 20th-century abstraction is also the result of an effort to discover meaning beyond the physical. Despite the enlightenment and the secularization of the arts, modern abstraction reveals a search, albeit at times apart from Christ, for spiritual truth.

Abstraction is often seen as an elimination of the image or representation. Viewed this way, abstraction is a form of iconoclasm. Throughout history, iconoclasm has been motivated by a rejection of physical reality and its representation. The first iconoclastic controversy, back in the middle of the first millennium A.D., was based on an interpretation of the Second Commandment prohibiting images made for the purpose of worship. The idea of worshiping sculpture was especially relevant because of the number of classical models still in existence. The controversy was also affected by the theological understanding of the divine nature of Christ. As the Son of God, he was beyond imaging. It was thought that realistic representations of Christ emphasized his physical humanity over his spiritual status. Portrayals of a human Christ were thought to minimize his divinity. The prohibition was overturned because of the belief that God himself had presented his nature in physical form, Jesus, being a representation of God and the recipient of our worship. If Jesus can be worshiped, then pictures presenting his image and those of other saints can also lead us to worship not the image, but the source of the original incarnation. Although iconoclasm was not sanctioned, the promotion of Christ's divine nature led to a dematerialized image, stylized and abstract. The body was symbolized rather than represented. The whole emphasis on the spiritual understanding of reality was revealed in medieval abstraction. What appears to be incompetent draftsmanship and loss of skill is essentially expressive of an immaterial "otherworld." Art always reveals what is valued most highly by a culture.

Artists are adverse to iconoclasm. It has destroyed significant parts of art's history. But abstraction's pursuit of the immaterial or spiritual,

and its banishment of the representational image, set it clearly and conceptually in line with that more violent destruction of images.

By the beginning of the 12th century, images, icons, and even architectural sculpture had proliferated to the point that a milder version of iconoclasm emerged. Bernard of Clairvaux, the founder of the Cistercian order, demanded that monks eliminate "all precious and beautiful things for Christ's sake … all things fair to see or soothing to hear, sweet to smell, delightful to taste, or pleasant to touch." He criticized the "…mundane splendor of Cluniac churches, their vast size, their 'costly polishings, their curious carvings and paintings which attract the worshipers gaze and hinder his attention.'"[2] The Cistercian architecture that was being built under Bernard's influence reflected his theology, stressing purity of outline, simplicity, and a form and light peculiarly conducive to meditation.[3] Suger had been influenced by Bernard, but the style of Cistercian churches rejected the increasingly frivolous and abundant decoration in favor of simple, harmonious proportions and unadorned spaces. In the midst of a Christian abstract art, a kind of minimalism emerged, and it was associated with meditation.

Although the mendicant followers of St. Francis of Assisi embraced the austerity program of St. Bernard's Cistercians, it was St. Francis' appreciation of nature as God's good gift, expressing his divine nature, that at least partially led to the opening of the Renaissance mind to the possibilities of studying the physical world. The rediscovery of classical ideas also contributed to the pursuit of realism and to another era that saw the

production of images in large numbers.

Art is used by the church to instruct, to decorate, and to redeem. Art works (icons) and sacred objects reminded the people of God's power—the power of truth, the power of beauty—and the result was an interest in the power of the object itself, a power that could be harnessed or exploited (i.e., money could be made off of it). By the 16th century, if Christians were not worshiping icons,

UNTITLED
LIST 6
1981
WATERCOLOR
AND INK
ON PAPER
20″ x 15″

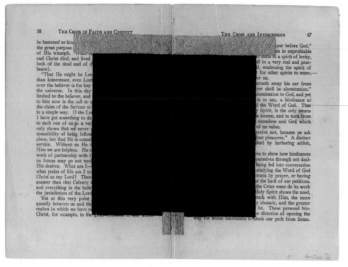

A Puritan ethic of hard work and minimal luxury extended iconoclasm by denying the visual arts any place in the church. The resulting culture of iconoclasm, evolving from the reformation, permeates 20th-century society. The church remains distant, on the one hand fearful of the sensuous, and on the other, certainly unable to recognize in its own heritage abstraction's pursuit of essences. Oddly, there are places where Christian faith intersects dramatically with 20th-century abstraction. Perhaps some of the most eloquent examples of minimalism are provided by Amish quilts, with their severe geometry, rich coloration, and meticulous construction. Next to these, the most drastic advances toward "pure" abstraction were conducted by two Russians—Kandinsky and Malevich, both with close ties to Christian Orthodoxy, icons, and the spiritual. Both were among the earliest to clear all representation from their painting.

Despite, or maybe because of, the disconnection of the visual arts from the church in the 20th century, iconoclastic abstraction has dominated. Regardless of artists' intentions, abstraction reflects the otherworldly, the immaterial, and the spiritual with symbolic forms promoting the pursuit of the divine over the image of the physical. Suger's and Bernard's aesthetic prevails. For them there was a message in the basic visual elements and forms. Theirs was not a contentless formalism. Formalism, as we understood it in the 1970's, was probably more a result of the academicization of abstract art. Students could learn the techniques of design and composition while spiritual content was deemed inappropriate for public and

images, and relics, they were at least spending an inordinate amount of time and money on them. The clergy had found a way to profit from the devotion given pictures of saints, Christ, and Mary.

Two crucial activities to which the rebelling protesters objected was the selling of indulgences and the irrational sense of devotion to images that the clergy used to control people. The Reformers' objections led to another version of iconoclasm. They ransacked churches, toppling statues and burning icons. They purged and "purified" religious practice, saved money, and put people to work on practical things. The relationship between the visual arts and the church began to change, especially in Protestant denominations. Church patronage diminished. Art became more of a commodity with a reduced role in church life. Groups protesting image abuse fled Counter-Reformation persecution and landed in America.

UNTITLED

BOOK PAINTING

(TCIFAC 58 & 47)

1988

GOUACHE ON

BOOK PAGE

7" x 10"

124

THE ART OF **GUY CHASE**

even Christian (if there was any—Christian college art departments blossomed in the 1960s) art education.

So now, for most of us, abstraction has come to mean "without content." We can even talk about the abstract composition of Leonardo's *Last Supper* or of Ed Knipper's *Dance of Salome*, and by so doing we will discuss form and color, lines and balance, avoiding their impact on the expression of meaning. The late 19th-century painter Maurice Denis led us in this direction when he wrote, "A picture, before being a warhorse, a nude, or some anecdote, is essentially a surface covered with colors, arranged in a certain order." To actually see things this way, one would have to be newborn, one to whom the whole world appears as colors arranged in a certain order. Meaning is what we figure out, what we make up, or what we interpret from the arrangement of forms and colors. From our first efforts at assigning meaning, we cannot go back to seeing without interpreting. We surely cannot talk about forms without assigning meaning.

If abstract means "without content," then, as Pablo Picasso said, "There is no abstract art." Everything has meaning. To consider an art to be purely formal—that is, contentless—would be to view it as an infant would. On the other hand, to abstract something is often understood as an act of summarizing, drawing out its essence, or creating a shortened version. By this view, any representation, as it is something less than its original source, could be called an abstraction. A study in plastic verisimilitude by Vincent Shine, in that it is not actually a living or a dead weed, is an abstraction, something other than what it appears to be. Abstraction is, like most other categories in which we like to organize art history, an imperfect designation.

But still, we cannot avoid it. My approach to what at first seems to be the most meaningless art, the most minimal abstraction, something like a work by Robert Ryman or Carl Andre, comes from a classroom experience. I asked my students to bring to class things for "show and tell" that they thought were meaningless. Then I proceeded to discuss the meanings I found in their objects to illustrate that content is always available. One student pinned an empty, plastic bag to the bulletin board. I proceeded to interpret meaning from the plastic bag until she stopped me. It wasn't the bag that was meaningless, but that which was inside the bag. I thought for a moment about Jeff Koons' plexi-glass cases containing brand-new wet-dry vacuum cleaners. Was I confronting a vacuum in which nothing exists? And then I realized; if God is everywhere and there is nothing inside the bag, then the bag must contain only God. I can't believe I am telling you that a zip-lock baggie became for me, at that moment, a work of art, a thing of beauty and truth. I was inspired, perhaps, by God in the bag. I discovered that the most minimal work of art provides an opportunity to recognize God's presence; an opportunity, that is, to be quiet and listen.

ENDNOTES

1 William Fleming, *Arts and Ideas,* H.B.J. 1995. Page 214.
2 Honour and Fleming, *The Visual Arts: A History,* Prentice-Hall 1992. Page 339.
3 H. Gardner, *Art Through the Ages,* H.B.J. 1986. Page 374.

Anderson, Cameron J. and Bowden, Sandra, *Faith and Vision: Twenty-five years of Christians in the Visual Arts.* Square Halo Books, 2005. (reproduction, page 53, and biography, page 189)

Pongracz, Patricia C. and Roosa, Wayne, *The Next Generation: Contemporary Expressions of Faith.* (exhibition catalog) Museum of Biblical Art, New York, and Eerdmans Publishing Company. 2005 (pages 75-78 and 182-183)

Essay published as part of "Symposium on Community and the Arts," Image: Journal of the Arts and Religion, Summer 2003.

Painting reproduced on back cover of Membership Directory for CIVA, 2003-04

Stein, Lisa, "What you see isn't what you get, 'Really'", Art Scene–Chicago Tribune, Friday, May 16, 2003

Roosa, Wayne, "Re-Viewing: Ancient Religious Texts", Arts–The Arts in Religious and Theological Studies, Fourteen, One, 2002.

Prescott, Theodore, ed. Like a Prayer: A Jewish and Christian Presence in Contemporary Art, exhibiton catalog. 2001

Bellos, Alexandra, "Paper Chase" review of solo exhibition at the Forum for Contemporary Art, St. Louis, The Riverfront Times, June 19–25. 1996.

Duffy, Robert. "White Light on Quicksilver" review of solo ehibition at the Forum for Contemporary Art, St. Louis, The Riverfront Times, June 9. 1996.

Watkins, Mel. essay for *Still Painting* exhibition at the Forum for Contemporary Art, St. Louis. 1996.

Ullrich, Polly, "The Power of Pattern," review of Wood Street Gallery exhibit, Chicago, IL. New Art Examiner, May, 1995.

Harris, Paul A., "Art Review," review of solo exhibit at Towata Gallery, Alton, IL. St. Louis Post-Dispatch, Feb. 6, 1992.

Reich, Daniel, "14 St. Louis Artists," review of exhibition at the Blue Moon Gallery, St. Louis, MO. New Art Examiner, June, 1991

Bellos, Alexandra, "By the Numbers," review of solo exhibit at Schmidt-Markow Gallery 1709, St. Louis. The Riverfront Times, May 8-14, 1991.

Harris, Paul A., "Painting-by-the-Numbers Revisited." Review of Solo exhibit at Schmidt-Markow Gallery 1709, St. Louis. St. Louis Post-Dispatch, April 27,1991

Schmitendorf, Karen, 100 Works Offer Overview of St. Louis Art Scene," St. Louis Post-Dispatch. Oct. 24, 1990.

Levinson, Joan, "Sins of Omission; Art St. Louis V," The Riverfront Times. November 22-28, 1989

The Cresset—A review of Literature, the Arts and Public Affairs. Valparaiso University Press, Valparaiso, IN. April, 1989. Reproduction of drawing on cover

Albert, Sara, "Show Challenges Viewers..." Review of Icons/Objects exhibit at the Urban Institute of Contemporary Art. Entertainment Section of The Grand Rapids Press. May 2, 1989.

Lowly, Timothy, "Christian Images by Contemporary Artists." Article in the Banner, the Magazine of the Reformed Church. Dec. '88

Rubin, Michael G., "New Work at Timothy Burns Gallery." *The Saint Louis Globe-Democrat,* March 6, 1984.

2011

New Work at Draewell Gallery, Judson University, Elgin, IL

Retrospective. Olson Gallery, Bethel University, St. Paul, MN

2010

Feast Your Eyes, juried show at AZ Gallery, St. Paul, MN. November. Exhibiting three finished portraits: oil on inkjet print on canvas.

Group show at St. Martin's Table, Minneapolis, MN

Work: Curse or Calling, CIVA juried traveling show

Net and Web, (solo) show of new work at the Rowland Gallery, Greenville, IL

2009

In Process, group show at the Carlson Tower Gallery, North Park University, Chicago, IL

Grid and Web, (solo) Adams Hall Gallery, Wheaton College, Wheaton, IL

Space Available, Bethel University Art Faculty Exhibit, 9th Street Entry Gallery, St. Paul, MN.

Art and Text. Dadian Gallery, American University. Washington, DC. and Olson Gallery, Bethel University. Curated by Teresia Bush.

2007

New Paintings, (solo) Wilson Gallery, Anderson University, Anderson, IN

New Paintings ,(solo) 9th Street Entry Gallery, St. Paul, MN

2006

Open Studio, 1717 Yosemite, San Francisco, CA

Solo Exhibit, First Presbyterian Church, Wheaton, IL

2005

Artists' Books, Altered Books Metropolitan State College, St. Paul, Minnesota.

Actual Things with Their Own Colors (solo), New York Center for Art and Media Studies, New York.

Books Abound, Minnesota Center for Book Arts, Minneapolis, MN.

The Next Generation: Contemporary Expressions of Faith, curators: Patricia Pongracz and Wayne Roosa, Museum of Biblical Art, New York.

Minnesota Art Faculty Invitational, Minneapolis Foundation Exhibition.

Fine Arts Festival, Eastern Nazarene College, Boston, Massachusetts

BLUE JAY
INSTALLATION
(10 COLOR, OIL,
PAINT-BY-
NUMBER)
1991
OIL ON PANEL
(ten identical
panels on shelves,
each painted one
color from the
paint-by-number kit)
12" x 9" EACH

2004

Bethel University Art Faculty Exhibit, 9th Street Entry Gallery, St. Paul, MN

Solo Exhibition at Eastminster Presbyterian Church in Evansville, IN, Feb.–March, in conjunction with lecture series presented by author, Dr. Paul Maier.

CIVA (Christians in the Visual Arts) 25th Anniversary Silver Portfolio. Chosen to contribute an original print in edition of 50.

2003

Art with Text, juried exhibition. ArtCo Gallery, Minneapolis, Minnesotta

Really–curated by Tim Lowly, gescheidle (gallery), Chicago, IL. (rated one of five best gallery shows in *New City Chicago* Magazine)

2001

Not Flat–one person show, Eugene Johnson Gallery, Bethel College, St. Paul, MN

Solo Exhibition, Evangel College, Springfield, MO

Solo Exhibition, Greenville College, Greenville, IL

Artists in Residence Exhibition, with Michael Rudnick, Joan Bankemper, Beverly Smith, and Lynn Hull. Tryon Center for Visual Arts, Charlotte, NC

Like a Prayer: A Jewish and Christian Presence in Contemporary Art, curated by Ted Prescott, at Tryon Center's Spirit Square Galleries, Charlotte, NC

2000

Faith, Dynamite Gallery, Grand Rapids, MI

1999

In/visible, with John Bierklie, Lynn Aldrich, and Kevin Newhall, Calvin College, Grand Rapids, MI

Retro–Active: nine artists in two years at the Schaeffer Institute, St. Louis, MO

Actual Things, one person show, The Vault Gallery, Midtown Arts Center, St. Louis

1998

Prayer Square–one person show, Archer Hall Gallery, Greenville College, IL.

Sacred Art XVI, Graham Center Museum, Wheaton, IL. Purchase Award.

1997

Solo Exhibition, *The Highlights*, Schaeffer Institute, St. Louis, Missouri.

"The Spiritual Search in Contemporary Art" curated by John Wilson. DePree Art Center, Holland, MI. and Wabash College Art Gallery, Bloomington, IN.

Solo Exhibition, "Prophets and Jesters II," Lower Armington Center, Greenville College, Greenville, IL

1996

Holiday Exhibit, Towata Gallery, Alton, IL.

Solo Exhibition, Trinity Christian College, Palos Heights, IL.

"The Really Big Kitsch Show," curated by Douglas Dowd. St. Louis Design Center, St. Louis, MO

Still/Painting, fifteen year retrospective exhibition, The Forum for Contemporary Art, St. Louis, Missouri.

Sacred Art XIV, Graham Center Museum, Wheaton, IL. Honorable Mention

Prophets and Jesters, invitational. Archer Hall Gallery, Greenville, IL.

1995

Mirror of Creation, Graham Center Museum, Wheaton, IL.

Natural Abstraction, four person invitational with Tim Van Laar, Michael Ryan and Judy Ledgerwood. Carlson Tower Gallery, North Park College, Chicago, IL.

"RE-Manifesting the Sacred," juried exhibition, Bade Museum, Berkeley, California.

Games, juried exhibition, Art St. Louis Gallery. St. Louis Missouri.

Obsession, invitational. Wood Street Gallery, Chicago, IL

Power of Pattern, six person, invitational. Wood Street Gallery, Chicago, IL

1994

Codex: CIVA, limited edition artist's book. Invited to create one page in edition of 50. Graham Center Museum. Wheaton, IL

Solo Exhibition, Union University Art Gallery, Jackson, Tennessee

"Contemporary Visions" invitational curated by Jason Knapp, Anderson Fine Arts Center, Anderson, IN

1993

Ninth Annual "Art St. Louis" juried exhibition.

Two Person Show with Robert Eustace, Auginbaugh Fine Arts Center, Messiah College, Grantham, PA

CIVA Juried Exhibition, Auginbaugh Gallery, Messiah College, Grantham, PA

1992

Solo Exhibition, Roberts Wesleyan College, Rochester, New York

Two Person Show,with Steven Heilmer.Archer Hall Gallery, Greenville College, Greenville, IL

Solo Exhibition, oil pastels, Towata Gallery. Alton, IL

1991

"The Animal Show," Towata Gallery, Alton, IL

Solo Exhibition, Schmidt Gallery, St. Louis, Missouri.

Solo Exhibition, College Art Gallery, Gordon College, Boston, Massachusetts.

"New Work; 14 St. Louis Artists," Blue Moon Gallery, St. Louis, Missouri.

"Sacred Arts XII, Graham Center Museum, Wheaton, IL.

1990

Solo Exhibition, Wheaton College Art Gallery, Wheaton, IL.

Solo Exhibition, Wilson Gallery, Anderson University, Anderson, IN.

Sixth Annual "Art St. Louis" juried exhibition. St. Louis Artists Coalition, St. Louis, MO

Summer Exhibit of Gallery Artists, Towata Gallery, Alton, IL

"Sacred Arts XI," Graham Center Museum, Wheaton, IL. Purchase Award

Solo Exhibition, Archer Hall Gallery, Greenville College.

Solo Exhibition, McGaw Fine Arts Complex, IL College, Jacksonville, IL.

1989

Fifth Annual "Art St. Louis" juried exhibition. St. Louis Artists Coalition, St. Louis, MO.

13th Biennial Southern IL Artists' Competition. Mitchell Museum, Mt. Vernon, IL

Solo Exhibition, "Quiet Time." First United Methodist Church, Greenville, IL.

"Sacred Art 200," exhibition of religious art in honor of the General Assembly of the Presbyterian Church (U.S.A.). Civic Center Museum, Philadelphia, PA.

"Professional Artist's Exhibition, IL State Fair, Springfield, IL.

"First Annual St. Louis Artists Juried Exhibition: Spotlight on Drawing," St. Louis Gallery of Contemporary Art, St. Louis, MO.

Arthur Towata Gallery, Artists Exhibit, Alton, IL.

"Icon and Object" five person invitational, curated by Tim Lowly. Urban Institute of Contemporary Art, Grand Rapids, Michigan.

"Sacred Arts X" Graham Center Museum, Wheaton, IL

"Seventh Biennial Watercolor IL," Tarble Arts Center, Eastern IL University.

1988

"The Christian Image in Contemporary Art," juried, travelling exhibition: The Rice Gallery, Albany Institute of History and Art, Albany, New York; The Center Gallery, Calvin College, Grand Rapids, Michigan; Houghton College Art Gallery, Houghton, New York; Archer Hall Gallery, Greenville College; University Art Museum, Valparaiso University, Valparaiso, IN.

Holiday Exhibit, Arthur Towata Gallery, Alton, IL.

"Mid-America Biennial," Owensboro Museum of Fine Art, Owensboro, KY.

One Person Show, Northwest Nazarene College Art Gallery, Tampa, Idaho.

1987

"Realism Today," juried exhibition. Evansville Museum of Art and Science, Evansville, IN.

"Harper College Eleventh Annual Print and Drawing Exhibition," Harper College, Palatine, IL.

1986

New Artists Invitational, Arthur Towata Gallery, Alton, IL.

"The Sacred Image," invitational, travelling exhibit curated by Donald Forsythe: Auginbaugh Gallery, Messiah College, Grantham, PA.; Archer Hall Gallery, Greenville College; Judson College Art Gallery, Elgin, IL

"Sacred Arts VIII, Graham Center Museum, Wheaton, IL

1985

Harper College 9th Annual Print and Drawing Exhibition, Harper College, Palatine, IL

"Fifth Biennial Watercolor IL," Tarble Arts Center, Eastern IL University.

1984

"New Work" group exhibition, Timothy Burns Gallery, St. Louis, Missouri.

1983

"Showcase '83", juried, regional exhibition. Art Center Association, Louisville, KY

Art Faculty Exhibition, Archer Hall Gallery, Greenville College.

"Chicago Works on Paper—Abstracted," Curated by Susan Sensemann. Travelling exhibit: Wustum Museum of Fine Arts, Racine, Wisconsin; Chicago Cultural Center, Chicago, IL.

"Installation/performance," one person show. Archer Hall Gallery, Greenville College.

1982

"Professional Artist's Exhibition," IL State Fair, Second Place Award: watercolor.

"Choice Painting," regional, juried exhibition, University of Kentucky, Lexington.

1981

Art Faculty Exhibition, Archer Hall Gallery, Greenville College.

Painting Installation, The School of the Art Institute of Chicago.

1978 & 79

San Mateo Art Council Juried Exhibition, San Mateo, California.

1977

"Raspberry Monday Four Year Excellence Award," Eugene Johnson Gallery, Bethel College, St. Paul, MN

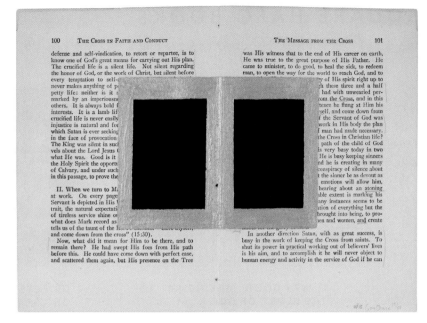

AUTHOR BIOGRAPHIES

James Romaine is an associate professor and art history department chair at Nyack College. He co-founded the Association of Scholars of Christianity in the History of Art (ASCHA). *ChristianityHistoryArt.org*

Joel Sheesley is a painter and professor of art at Wheaton College, Wheaton, IL. Recent work by Joel Sheesley was exhibited in 2010 at the Chicago Cultural Center. *JoelSheesley.com*

Theodore Prescott is a mixed media sculptor who writes frequently about art. He founded the art program at Messiah College, where he is an Emeritus Professor of Art. *TedPrescottSculpture.com*

Wayne Roosa is professor of Art History and Department Chair at Bethel University in St. Paul, as well as Chair of the New York Center for Art and Media Studies in New York City. *WayneRoosa.com*

Albert Pedulla is an artist who lives in the New York City area with his wife and three children. He has written about art for journals such as IMAGE, SEEN, and Comment. *Local-Artists. org/user/4891/profile*

UNTITED BOOK PAINTING (TCIFAC 100 & 101)
1988
GOUACHE ON BOOK PAGE
7" x 10"

SQUARE HALO BOOKS

EXTRAORDINARY BOOKS FOR ORDINARY SAINTS

IT WAS GOOD: MAKING ART TO THE GLORY OF GOD

"It Was Good is one of the best examples I know of the new day that is dawning in Christian conversation on the arts. What we have needed is a thick description both of Christianity and of art making. And both are here in abundance, along with generous displays of great art motivated by faith both from the present and the past."
—William Dyrness, author of *Visual Faith: Art, Theology, and Worship in Dialogue*

OBJECTS OF GRACE: CONVERSATIONS ON CREATIVITY AND FAITH

"[A] colorful and concise collection of interviews and art from some of America's most intriguing Christian artists. [James] Romaine interviews ten artists, presenting color reproductions of the artists' work along with the text of the interviews. Each artist dialogues on what it means for a Christian to engage in the creating process."
—*Image: A Journal of the Arts and Religion*

IN CHRISTIAN ART, THE SQUARE HALO IDENTIFIED A LIVING PERSON PRESUMED TO BE A SAINT. SQUARE HALO BOOKS IS DEVOTED TO PUBLISHING WORKS THAT PRESENT CONTEXTUALLY SENSITIVE BIBLICAL STUDIES, AND PRACTICAL INSTRUCTION CONSISTENT WITH THE DOCTRINES OF THE REFORMATION. THE GOAL OF SQUARE HALO BOOKS IS TO PROVIDE MATERIALS USEFUL FOR ENCOURAGING AND EQUIPPING THE SAINTS. TO SEE ALL OF THE TITLES FROM SQUARE HALO BOOKS, VISIT:

WWW.SQUAREHALOBOOKS.COM